Splendors of Ancient Egypt

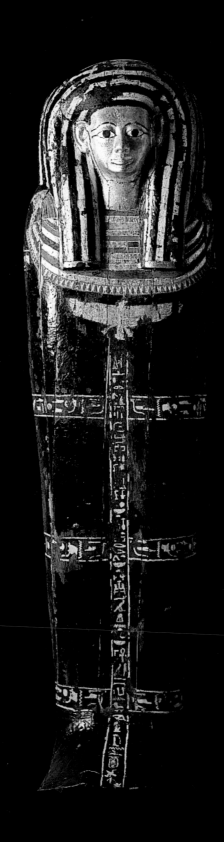

SPLENDORS OF ANCIENT
EGYPT

William H. Peck

THE DETROIT INSTITUTE OF ARTS

ABBEVILLE PRESS PUBLISHERS
NEW YORK LONDON PARIS

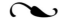

This book is published in conjunction with the exhibition "Splendors of Ancient Egypt," organized by the Florida International Museum, St. Petersburg, and selected from the collections of the Roemer and Pelizaeus Museum, Hildesheim, Germany.

All objects illustrated are from the Roemer and Pelizaeus Museum and were included in the exhibition "Splendors of Ancient Egypt."

Florida International Museum, St. Petersburg
 February 6 – July 7, 1996
Museum of Fine Arts, Houston
 September 22, 1996 – March 30, 1997
Detroit Institute of Arts
 July 16, 1997 – January 4, 1998
Portland Art Museum, Oregon
 March 8 – August 16, 1998
Phoenix Art Museum, Arizona
 October 1998 – April 1999

The exhibition was made possible in Detroit with the support of the Chrysler Corporation Fund, the Michigan Council for Arts and Cultural Affairs, and the DIA Founders Society, with additional funding for educational programs provided by Kelly Services.

ISBN: 0-7892-0451-7
For the Detroit Institute of Arts:
 Director of Publications: Julia P. Henshaw
 Editor: Judith A. Ruskin
 Design: Mike Savitski, Ann Arbor, Michigan

Printed by University Lithoprinters, Inc., Ann Arbor, Michigan
First Abbeville Edition

10 9 8 7 6 5 4 3 2 1

For all illustrations, dimensions are approximate; height precedes width, unless otherwise indicated. Caption abbreviations: *h.*=height, *l.*=length, *diam.*=diameter.

Front Cover
Anthropoid Sarcophagus of Amen-em-opet *(detail)*
New Kingdom, Dynasty 18, about 1490 B.C.
Painted and gilded wood

Frontispiece
Anthropoid Sarcophagus of Paser
New Kingdom, Dynasty 18, about 1420 B.C.
Painted and gilded wood. From Thebes

Back Cover
The Deified King Tuthmosis I *(detail)*
New Kingdom, about 1465 B.C.
Painted limestone. From Western Thebes,
Deir-el-Bahri, Temple of Queen Hatshepsut

Library of Congress Cataloging-in-Publication Data

Peck, William H.
 Splendors of ancient Egypt/William H. Peck
 p. cm.
 Includes bibliographical references (p. 87) and index.
 ISBN 0-7892-0451-7 (pbk.)
1. Egypt—Civilization—To 332 B.C. 2. Egypt—Civilization—332 B.C.–640 A.D. 3. Art, Egyptian. I. Title.
DT61.P43 1997
932—DC21 97–19806

CONTENTS

1 HISTORY

5 THE LAND

15 THE PEOPLE

29 THE NOBILITY

51 RULERS

61 GODS & GODDESSES

73 THE AFTERLIFE

86 Selected Gods and Goddesses of Egypt

87 Suggestions for Further Reading

88 Index

Wilhelm Pelizaeus (1851-1930) examines one of his Egyptian objects in this photo taken in about 1907 at his home in Cairo. Pelizaeus donated his outstanding collection, including the *Seated Statue of Nefer-ihi (see page 32)* visible to his right in the lower cabinet, to the Roemer Museum in his hometown of Hildesheim.

THE EXISTENCE of the spectacular collection of ancient Egyptian works of art from the Roemer and Pelizaeus Museum in Hildesheim, Germany, has been virtually unknown to American audiences. "Splendors of Ancient Egypt," a touring exhibition of more than two hundred pieces from the German museum, goes far in remedying this lack of familiarity. On the occasion of the exhibition's Detroit visit, it gives me great pleasure to add to the knowledge of these treasures with the publication of this general introduction to the culture and history of ancient Egypt, illustrated entirely from the diverse objects displayed in the show.

The extensive collection of Egyptian art in Hildesheim had its beginning in 1870 when Hermann Roemer, one of the founders of the museum that bears his name, traveled to Egypt and collected artifacts. It was not until 1879, however, that William Pelizaeus, a native of Hildesheim living in Egypt, began his donations of Egyptian antiquities to the institution in his hometown. At that early time, the idea of a separate Egyptian Room within the Roemer Museum began to develop; but by the time Pelizaeus donated his considerable private collection to the city of Hildesheim in 1907, a separate facility was envisioned solely for Egyptian art. After many delays, the new Pelizaeus Museum opened in 1911 in a building that had originally served as an orphanage and was next to the site of the Roemer Museum.

In the early years of this century, Pelizaeus saw the advantage of contributing to the support of excavations carried out in the Giza necropolis by the University of Leipzig

and the Academy of Sciences of Vienna. As a result of his support, and the practice at that time of awarding finds to excavators, the Pelizaeus Museum became especially rich in the art of Egypt's Old Kingdom. This explains, in part, the presence in the collection of the life-sized statue of Hem-iu-nu, nephew of Khufu and architect of the Great Pyramid at Giza. Among statues from this period in Egypt's history, the seated figure is extraordinary for its size and the representation of a powerful and influential nobleman.

The First World War and the ensuing rampant inflation of the early 1920s severely hampered the two museums, but despite years of adversity the collections continued to grow. Following the outbreak of World War II, the entire Pelizaeus collection was removed from the museum or secured in vaults. All but one of the museums' buildings, the converted orphanage, failed to survive the 1945 destruction of Hildesheim. The two museums were rebuilt on the same site and reopened in 1959 as one entity, the Roemer and Pelizaeus Museum.

The restored museum serves as a testament to the determination of the citizens of Hildesheim to protect and display their artistic and cultural treasures. Pelizaeus's dream for a comprehensive historical overview of Egyptian art and culture has been fulfilled and has prospered with continual additions of new material to the collection Pelizaeus himself so lovingly built. While individual works from the museum have been loaned to important exhibitions, this is the first time a comprehensive survey of the Egyptian collection has been available to tour. "Splendors of Ancient Egypt" was first displayed at the Florida International Museum, St. Petersburg, in 1996 before embarking on a North American odyssey with stops in Houston, Detroit, and Portland, Oregon.

We are much indebted to Dr. Arne Eggebrecht, director-general of the Roemer and Pelizaeus Museum for his unstinting cooperation in every aspect of this tour; Dr. Annamaria Geiger, director of cultural affairs for the city of Hildesheim; and the mayor of Hildesheim, Kurt Machens. In this country, our thanks go to Joseph F. Cronin, president, and the personnel of the Florida International Museum, St. Petersburg, and to Peter Marzio, director, and the staff of the Museum of Fine Arts, Houston.

In Detroit, William H. Peck, senior curator and curator of ancient art, organized the exhibition and wrote this introductory guide. Mike Savitski of Ann Arbor created the outstanding design of the book, which was edited by Judith A. Ruskin of the DIA publications department. The exhibition was made possible in Detroit with the support of the Chrysler Corporation Fund, the Michigan Council for Arts and Cultural Affairs, and the DIA Founders Society, with additional funding for educational programs provided by Kelly Services. I extend my sincerest thanks to those mentioned above as well as to the many staff members of the Detroit Institute of Arts who devoted so much time and energy to making this exhibition a success.

Samuel Sachs II
Director, The Detroit Institute of Arts

Mediterranean Sea

N

0 mi 30 60
0 km 50 100

Alexandria •

Port Said •

Mendes •

Qantir •

Kom Abu Billou • • Bubastis

Libyan Desert

Giza • • Cairo

Saqqara •

Sinai

Faiyum •
Medinet Gurob • • Abusir el-Meleq

• el Hiba

el Minya •

Tuna el-Gebel •

• Tel el-Amarna

Arabian Desert

Meir •

Asyut •

Nile

• Akhmim

Red Sea

• Thebes

Esna •

Area of Detail

Edfu •

AFRICA

• Aswan

GYPT, SITUATED IN the northeast corner of Africa, at the crossroads between the countries of the ancient Near East, the lands around the Mediterranean Sea, and the rest of Africa to the west and south, is generally considered one of the world's oldest civilizations, with a history continuing unbroken for thousands of years. Egypt became a unified country around the year 3000 at the beginning of the third millennium B.C. The physical layout of the country, a long narrow strip of cultivated land in the midst of barren desert, contributed to its partial isolation from the rest of Africa and the continuation of its special customs and practices. In periods when

HISTORY

the central government was strong the country remained unified; however, each of the three eras of Egyptian greatness—called the Old, Middle, and New Kingdoms by modern historians—was interrupted by times of disunity and divided power now termed "intermediate" periods.

The formation of a structured society under clan or tribal leaders developed during the Predynastic Period in the approximately one thousand years leading up to the beginning of written history and the unification of Egypt under one ruler. Since there were no written records, everything known about this period is derived from archaeological excavations of cemeteries and early settlements. The earliest forms of burial included the placement of personal possessions in the grave, indicating a desire to prepare for some form of life after death.

The Old Kingdom, lasting roughly five hundred years, was the age of the pyramid builders. The very greatness of Egypt is, in many people's minds, symbolized by the three largest pyramids at Giza, built in the twenty-sixth century B.C. While it may have taken twenty years or more to build a single pyramid, the pyramid age lasted less than one hundred years, a very short time in the overall span of Egyptian history. Many of the customs and traditions now associated with the ancient Egyptians, such as standards of artistic representation and the preparation of the body for life after death, were formulated during the Old Kingdom.

The second great era, the Middle Kingdom, lasted for about four hundred years. It was characterized by a series of strong rulers who reunified the country after the disruptions of the First Intermediate Period and extended Egypt's borders to the east and the south. The period was also one of intellectual development and the rise of a strong literary tradition, from which many classic texts have been preserved.

The New Kingdom, in existence for almost five hundred years, was a period of international expansion and contacts with other peoples and cultures. It was a time of high achievement in the arts and crafts, perhaps enhanced and accelerated by these contacts. It was during the New Kingdom that the ruler Akhenaten tried to reshape Egyptian

Predynastic Period
7000 B.C.–3100 B.C.

Archaic Period
3100 B.C.–2700 B.C.

Old Kingdom
2700 B.C.–2200 B.C.

Age of the Pyramids

First Intermediate Period
2200 B.C.–2040 B.C.

Middle Kingdom
2040 B.C.–1640 B.C.

3500 B.C. 3000 B.C. 2500 B.C. 2000 B.C.

Early pottery

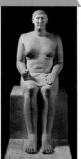

Tomb statue of Vizier Hem-iu-nu

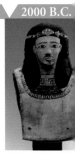

Head covering from the mummy of a nobleman

politics, culture, and religion and moved the capital to Akhtaten (modern-day Tel el-Amarna) from Thebes. His changes, however, did not survive his relatively brief reign.

For almost all of the last thousand years of ancient Egyptian history, the country suffered from periods of disunity as well as foreign invasion and occupation by Kushites from the south, Assyrians and Persians from the east, and Greeks and Romans from the north. Much that is considered typically Egyptian, such as small bronze statues of gods and sacred animals, date from this time. Some of the best preserved and most familiar of the ancient Egyptian temples were constructed during the rule of the Greek Ptolemaic Dynasty or by the later Roman occupiers.

The apostle Mark is said to have brought Christianity to Egypt in the first century A.D. Christian Egyptians, a minority in the country, were and still are known as Copts. Coptic art was a hybrid of Greek and Egyptian artistic traditions. By the time of the invasion of Arab Muslims in the seventh century A.D., the customs and religion of the ancient civiliza-

tion had been virtually forgotten.

In addition to the broad divisions of Old, Middle, and New Kingdoms, Egyptian history is also divided into dynasties—families or groups of related rulers. There are thirty-one recorded dynasties, not all of which were of equal importance. Some dynasties overlapped and coexisted with others, and it is not always clear why one dynasty replaced another. This division of Egyptian history was devised by a Greek priest, writing at the beginning of the third century B.C., when the country was ruled by followers of Alexander the Great.

Foreigners were often the source of information on ancient Egypt, for the Egyptians themselves did not leave comprehensive accounts of the country as understood by the modern concept of recorded history. The culture's complex past has been reconstructed through archaeological discoveries, inscriptions found in temples and tombs, lists of kings, and the records left by the people of other cultures. New discoveries are continually being made, providing fresh and changing interpretations of the ancient past.

| cond termediate riod 40 B.C.-50 B.C. | New Kingdom 1550 B.C.-1070 B.C. | Third Intermediate Period 1070 B.C.-712 B.C. | Late Period 712 B.C.-332 B.C. | Ptolemaic (Greek) Period 332 B.C.-30 B.C. | Roman Period 30 B.C.-395 A.D. |

1500 B.C. 1000 B.C. 500 B.C. A.D.

Head of statue of Ramesses II

Statuette of the god Osiris

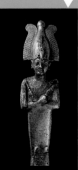

The Book of the Dead of Djed-hor

IT IS NOT AN EXAGGERATION to say that the Nile River was the soul of Egypt, for without the river the country would not have existed. Early visitors recognized the river's importance: the early Greek historian Hecataeus stated that "the land of Egypt is the gift of the river." Not only did the life-giving water permit agriculture in an otherwise arid area, but the annual flooding of the Nile, a result of the rainy seasons far to the south in central Africa, renewed the land with mineral-rich clay and silt deposits brought from the highlands with the inundation. The high water created the fertile lands of the Nile Delta and, during the flood season, filled the river channel and

THE LAND

Early Pottery

Predynastic Period, before 3200 B.C.
Fired clay; h. 4½ in. (11.3 cm)

From the very beginning of Egyptian history, potters showed an awareness of their natural surroundings in the Nile Valley and the grasslands beyond, decorating their wares with stylized mountains, horned animals, and long-legged birds. Scenes of many-oared Nile boats, such as the one on this Predynastic pot, are complete with deck cabins and insignia and contain some of the first human figures found in Egyptian art.

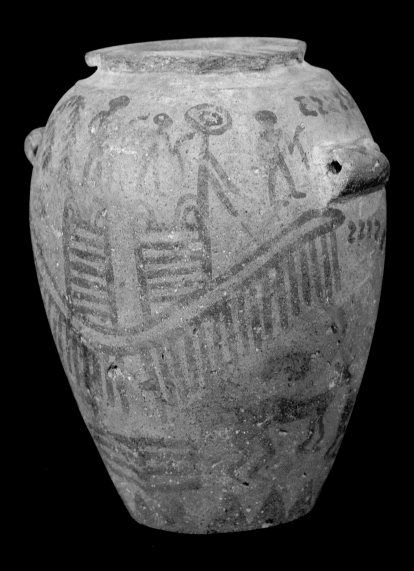

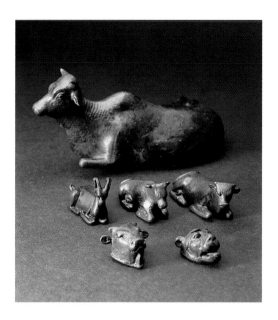

Six Scale Weights in Animal Form

New Kingdom, Dynasty 18, about 1400 B.C.
Bronze, lead, and gold; largest: l. 6 ⅛ in. (15.4 cm)

Weights in the form of animals were used to measure gold and other precious materials. This group includes a horned ibex, reclining bulls or cows, and the heads of a bull and a lion, an interesting mixture of domestic and wild animals found in the Nile Valley.

spread across the fields of the flood plain to a depth of as much as five feet. In old photographs, taken before the building of the present Aswan Dam, boats can be seen sailing in and around the temples.

The river Nile was the main artery for transportation, providing the link and unifying highway from south to north. The prevailing winds from the north facilitated navigation under sail to the south, going against the current. Wheeled vehicles came relatively late to Egypt (no earlier than the seventeenth century B.C.) because the early development of boats, barges, and rafts was far more important to a river-based culture.

The Nile was important in yet another way, influencing the Egyptians' acceptance of the cyclical nature of existence and the belief that history would repeat itself. The regularity of the annual flood, on which so much depended, was seen as a gift of the gods. If the gods were not properly worshipped, they might take out their wrath on the rulers and the people by causing the waters to be too low or too high. The coming of the flood was seen as one of the regular cycles of life, like the rising and setting of the sun and the movement of the stars. The Egyptians viewed life and history as a series of such cycles, endlessly repeating themselves as long as order was maintained by the rulers, and the gods saw fit. The observation of the cycles of nature allowed the Egyptians to develop a 365-day calendar as a means of marking time and predicting the annual flood.

The country's pattern of life was basically established in the early prehistoric period, between 17000 and 15000 B.C., when the

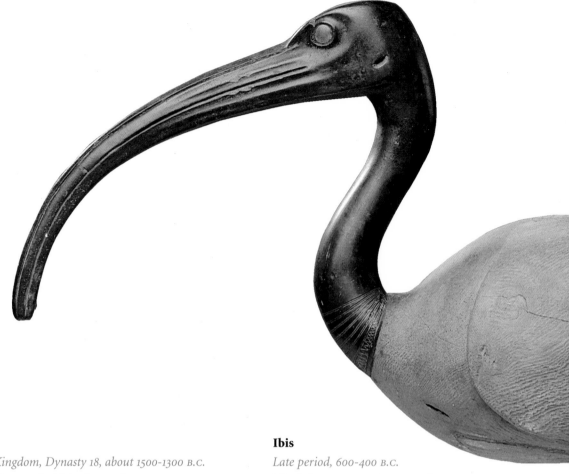

Fish

New Kingdom, Dynasty 18, about 1500-1300 B.C.
Carved stone; l. 3⅞ in. (9.7 cm)

The fish of the Nile were an important part of
the Egyptian diet. Images of fish were used in the
design of many utilitarian and decorative objects
such as this small dish used to hold some form of
cosmetic material.

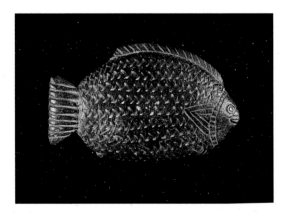

Ibis

Late period, 600-400 B.C.
Wood, bronze, gesso, jasper, and
* remains of gilding; h. 16⅛ in. (41 cm)*

The ibis, a long-legged water bird from the marsh
land of the Nile and its delta, was sacred to the
god Thoth. Thoth was revered for his wisdom
and was regarded as a divine judge as well as the
inventor of speech and calculation. As the scribe
of the gods, he became the patron of writing
and the written arts in general. This sculpture
was made as a votive offering to the god.

peoples of northeast Africa ceased their nomadic existence and settled on the banks of the Nile River. There they developed methods and techniques for raising both crops and animals. Throughout its history, Egypt has been an agricultural country, with the lives of all classes of people very much attached to the land and its produce. The predominately rural life of farm and estate was dominated by the necessity to produce food. The great civilization of Egypt was essentially based on its ability to grow crops, which was significantly improved by the Nile's fertilization of the land. The Old Testament story of Joseph, from the Book of Genesis, is a good illustration of the area's bounty. Joseph's brothers went "down to Egypt" to beg him for grain in time of famine in their native land. The story presents a vivid picture of the rich Nile Valley, capable of producing food not only for its own people but also for those from neighboring countries. This ability to grow ample crops made Egypt an attractive country for conquest.

Both the wild and domesticated animal life of Egypt is wonderfully illustrated in ancient art forms. Birds and beasts of all kinds can be found in large numbers in tomb and temple wall carvings and paintings and as three-dimensional objects. Scenes of hunting and fishing in the marshes, the raising, nurturing, and ultimately the slaughter and preparation of animals for food abound. The sowing of the seed, reaping, and threshing of the grain are shown in great detail.

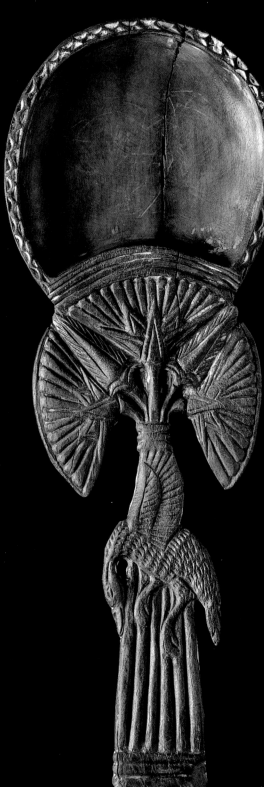

Cosmetic Spoon

New Kingdom, Dynasty 18, about 1320 B.C.
Wood; h. 6¾ in. (17.2 cm)

This spoon has the general shape of an *ankh*,
the abbreviation for the hieroglyphic word "life,"
although the addition of the bouquet of lotus
flowers suggests the idea of rebirth. The dead
duck or goose bound into the bouquet by its
wing tip serves as a reminder of death. Such
spoons were presumably used to hold cosmetics
or ointments.

Architectural Decoration with Floral Motifs

New Kingdom, Dynasty 18, 1550-1307 B.C.
Faience; l. 3 ½ in. (9 cm)
From Tel el-Amarna

This small faience plaque was once a part of the decoration of a palace at Tel el-Amarna, the short-lived capital of the king Akhenaten. His single devotion to the sun god as the giver of all life was often expressed through decorative means.

Sleeping Hippopotamus

Middle Kingdom, Dynasty 12, 1850 B.C.
Faience; l. 5 ⅞ in. (15 cm)

To the Egyptians, the hippopotamus could represent the forces for either good or evil. Its size and strength marked it as a menace to be overcome, and it was often shown as the quarry in hunting scenes. In sharp contrast, charming figures such as this one, with bright blue glaze and painted designs of lotus flowers, probably had positive connotations related to fertility and the Nile as a source of regeneration.

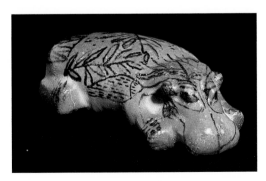

Birds played an important part in the life of the Nile Valley, and connections developed between some winged species and the Egyptian gods. The falcon, for example, was associated with the celestial god Horus and the bird, as a representation of the present ruler or "living Horus," was an important symbol of Egyptian kingship. The ibis, long-legged with a long, curved beak, was associated with the god Thoth, the patron of scribes and of learning in general. Many images of birds appear as hieroglyphic signs in the Egyptian language, probably because bird life was so much a part of the visual imagery of the land.

Foreigners who visited Egypt in antiquity were particularly impressed by two animals, the hippopotamus and the crocodile, both found only in that location. The crocodile was associated with the god Sobek; the hippopotamus was considered as a symbol of both evil and beneficence. The male hippo, who often trampled and devoured crops, was seen as a menace and was often depicted as the quarry in hunting scenes. The female of the species was associated with one of the most popular household gods, Taweret, who was of particular importance to women in childbirth. Charming sculptures of the hippo, crafted in blue faience with lotus flowers and butterflies painted on its back, are probably a reference to fertility and to the Nile as a source of regeneration.

The plant life of the Nile, in the marshes and along the riverbanks, was a constant resource and inspiration for the creation of decorative arts. Papyrus reeds provided the raw material for the manufacture of writing

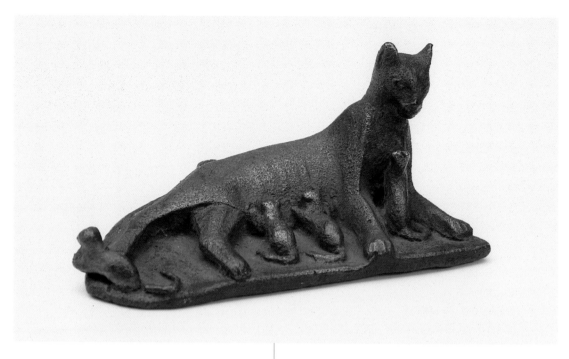

Cat with Kittens

Late Period, about 600-500 B.C.
Cast bronze; l. 3 ¼ in. (8.2 cm)

The cat was the animal associated with Bastet, the goddess of the city of Bubastis. An elegant seated feline is the most familiar depiction of this sacred animal; small informal statuettes such as this one were intended to show the maternalistic nature of the cat.

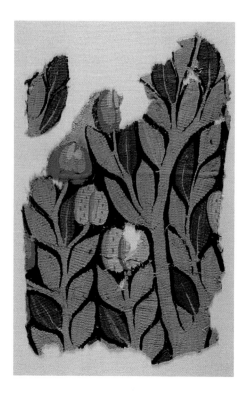

Fragment of a Wall Hanging

Coptic Period, 3rd-7th century A.D.
Linen and wool; 15 ¾ x 23 ⅝ in. (40 x 60 cm)

The fertile areas watered by the Nile were in stark contrast to the desert sands and the mountains beyond. This piece of weaving from the Christian era in Egypt is a vivid illustration of the regard for lush vegetation and need for bright color in a land dominated by the surrounding desert.

Stela of Cherdu-ankh

Ptolemaic Period, about 200-100 B.C.
Granodiorite; h. 33 in. (83.8 cm)

The scene at the top of this stela, or commemorative marker, shows offerings being made to the various gods on behalf of the deceased Cherdu-ankh. The lengthy hieroglyphic inscription below includes prayers for her and records the manner of her death: she met her fate while swimming in the Nile where she was attacked and killed by a crocodile. While the Nile River was of the utmost importance to life in Egypt, it could also be the source of misfortune.

surfaces. Lotus and lily flowers were symbolic of the two lands (the north and south), which had been united at the beginning of history to form Egypt, but the lotus as a bud and a blossom was also an important symbol of rebirth and resurrection. Plant and animal images served not only as simple decorations but as symbolic representations of important ideas and beliefs as well.

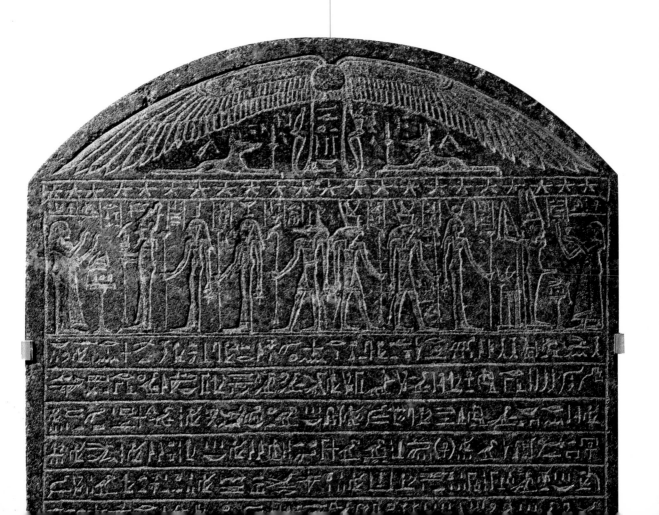

HE EGYPTIANS left one of the most complete and detailed records of daily activities, through objects preserved in graves and tombs, of any people in the ancient world. As early as the Predynastic Period, cookware, utensils, cosmetic items, and jewelry were placed in graves for the use of the deceased in the afterlife. Small sculptures, pottery decoration, and tomb paintings and reliefs depicted many of the routine tasks undertaken by the men and women of Egypt. ∾ Throughout its history, Egyptian society was carefully structured in a manner not unlike a pyramid. There was a large peasant or working class that formed the basis upon which society

THE PEOPLE

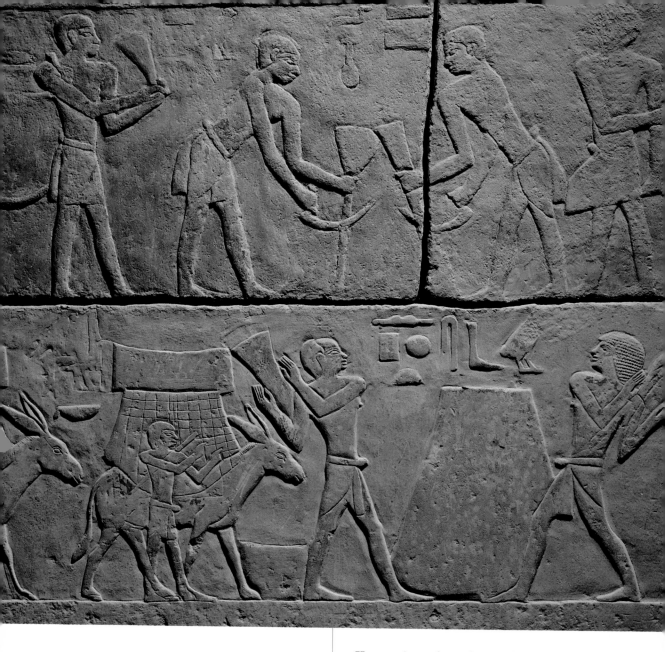

Harvest Scene from the Tomb of Sesh-em-nefer IV

Old Kingdom, Dynasty 6, about 2280 B.C.
Painted limestone; 33 ¼ x 39 ⅜ in. (84.5 x 100 cm)
From Giza, tomb LG 53

Egyptian tombs were decorated with scenes meant
to supply the spirit in the next life with every con-
ceivable need. This small segment shows workmen
with curved sickles harvesting grain, which will be
transported on donkeys to a granary for threshing.
A short inscription above the donkey can be trans-
lated as "get along," and that over the workmen as
"pile up the grain." Such texts in reliefs are often
simple descriptions of the action shown.

rested; there was a smaller elite ruling class, which controlled the government and the military; and the king and the royal family were at the apex or top of the pyramid. Simple laborers toiled in the fields, in the mines, or on construction projects and produced all manner of foodstuffs and goods. Women's lives essentially centered around the home and family, but some women had their own businesses and were able to help support their dependents. People lived in simple houses of two or three rooms made of unbaked mud brick, an abundant material derived from the soil of the Nile River bottom that was the basis of domestic architecture for all classes. During the Old Kingdom, the mastaba tombs (so-called from the Arabic word for "bench") imitated in stone the shapes of these mud-brick dwellings.

The working classes were usually depicted dressed in simply designed garments, typically kilts or loincloths for the men and undecorated shifts for the women. Linen, made from the flax plant, provided the main material for clothing; cotton was not introduced into Egypt until late in its history. The diet was simple, but, as indicated by food offerings left in tombs as well as depictions of such offerings, it included a variety of vegetables, fruits, meats, and fowl. If the inscriptions in tombs are accurate, the Egyptians consumed great quantities of bread and beer as well. Pottery was an important material in the home; storage containers, cooking utensils, serving dishes, and almost all other objects connected

Model of a Plowman

Middle Kingdom, Dynasty 11, about 2000 B.C.
Painted wood; l. 17⅜ in. (44 cm)

During the Middle Kingdom, three-dimensional models rather than wall paintings often provided the deceased with the essentials for the next life. Such models became elaborate depictions of daily life, including farming and food preparation. The plowing of the fields was the first step in producing two staples of the Egyptian diet—bread and beer, both made from grain.

Model of a Granary

Middle Kingdom, Dynasty 11, about 2000 B.C.
Painted wood; l. 17⅜ in. (44 cm)

In this miniature granary, the harvested crops
are collected and emptied into containers while
scribes keep a careful count of the quantities.
The field workers hold sacks of grain, while the
scribes have writing boards.

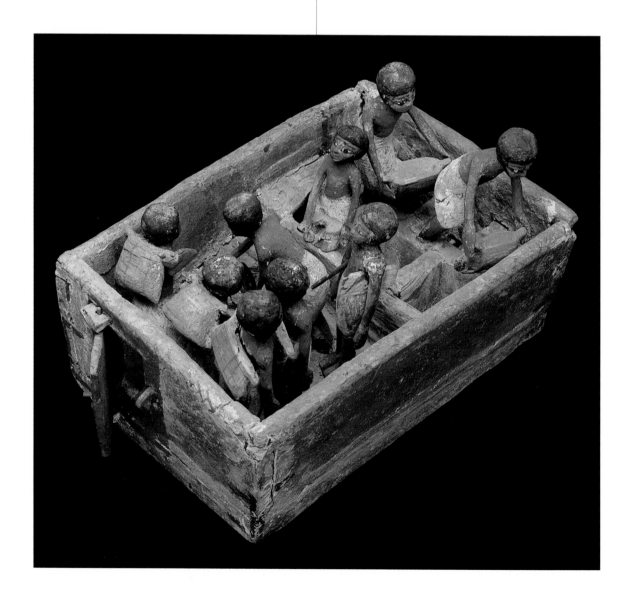

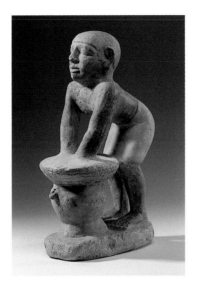

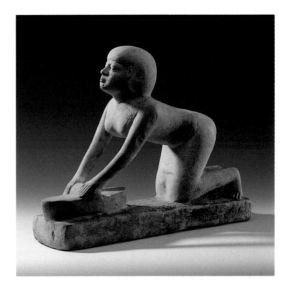

A Brewer
Old Kingdom, Dynasty 6, about 2280 B.C.
Painted limestone; h. 14¼ in. (36 cm)
From Giza, mastaba tomb D 39-40

A Woman Grinding Grain
Old Kingdom, Dynasty 6, 2310 B.C.
Painted limestone; h. 11⅝ in. (29.5 cm)
From Giza, mastaba tomb D 20

The production of foodstuffs was represented in tombs to help nourish the spirit and included depictions of workers engaged in specialized tasks such as making bread and beer. The brewer (*above left*) works mash through a basketry sieve into a beer vat while a women (*above right*) grinds grain for flour on a stone quern, a curved surface designed especially for that purpose.

with food preparation and consumption were made of fired and unglazed clay.

The working class had professional levels within it. Trained craftsmen, including potters, carpenters, weavers, metalsmiths, jewelry makers, and stone carvers, made various kinds of goods, from furniture and textiles to tools and weapons, and were considered a step above common laborers. Artists who carved statues and painted tomb decorations, while still considered craftsmen, were of a higher level of skill. Some craftsmen were rewarded with high rank, became overseers of groups of trained workers, and even had their own richly decorated tombs. The ancient Egyptians had no words that differentiated between the artist and the craftsman, and the modern notion that artists were somehow of a special category was unknown to them.

The scribe, who was trained to read and write, calculate and keep records, was on a still higher level. Scribes took great pride in the fact that they did not do manual labor. The profession was also an entry point into the government and could lead to a person's

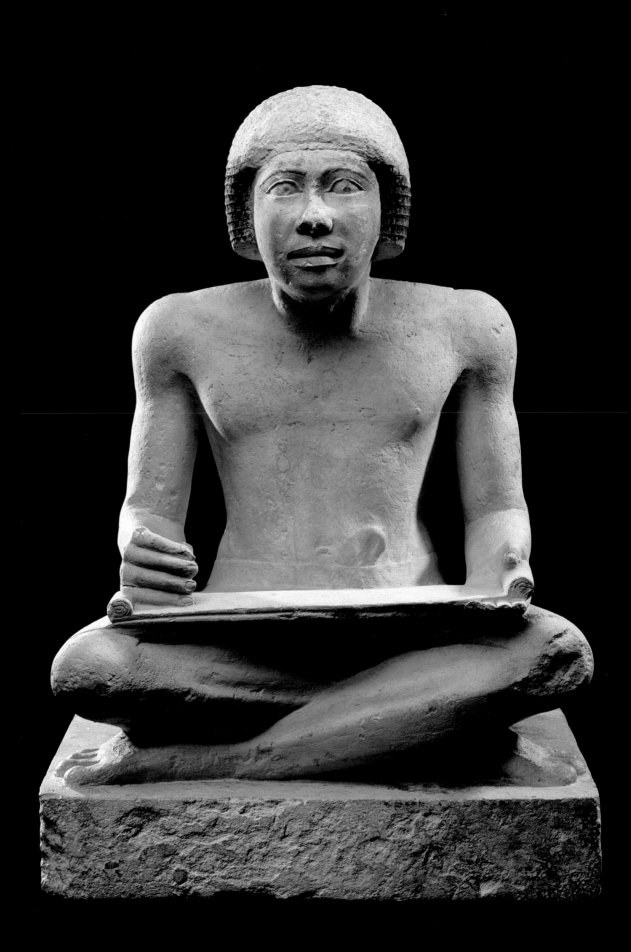

The Scribe Heti

Old Kingdom, Dynasty 5, about 2300 B.C.
Painted limestone; h. 20½ in. (52 cm)
From Giza, mastaba tomb G 2340

Literacy was the key to advancement in the ancient Egyptian government and bureaucracy. Heti, represented here, was a high-ranking overseer of scribes in the judicial branch of administration. He is seated cross-legged with his papyrus scroll stretched across his knees and his hand poised in the act of writing. His attention and gaze are not focused on his writing, but he seems attentive to inspiration from the gods.

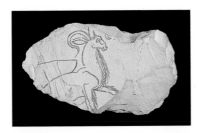

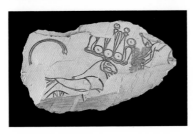

Two Drawings

New Kingdom, Dynasty 19, 1200 B.C.
Painted limestone; 7½ x 13⅜ in. (19 x 34 cm)
Probably from Thebes

Limestone chips served as sketch pads for Egyptian artists. Drawings appear on both sides of this piece of limestone. On one side of the stone, an artist has made a vigorous drawing of a horned animal, while on the reverse is a sketch of the sacred ram of the state god Amun.

advancement through the bureaucratic ranks. Priests and the priesthood were not a distinct separate class; generally, an individual served as a priest in addition to performing other governmental duties. Some occupations were hereditary and passed from father to son, as is often indicated in inscriptions detailing the same titles and duties for both generations. Women were able to inherit property and attain rank and title in religious circles if not in the government bureaucracy.

WRITING

The ancient Egyptian art of writing developed over more than three thousand years of continued use. Based on pictures, or pictographic, this language had three major forms and served every written need of a complex society, from simple record keeping to subtle literary texts. Although many signs functioned as the abbreviated forms of words and were used as protective charms, the language was not a code. It had an elaborate grammar, extensive vocabulary, and complex form, albeit written with pictures. The literate class made up a small portion of the population. The ability to read and write was the key to any occupation beyond common labor and the skilled crafts, and it was the one skill necessary for advancement in rank and responsibility.

In its earliest form, the writing consisted of simple pictograms meant to record important events. Not every sign or character conveyed a complete thought in and by itself; in fact, the system was based on a combina-

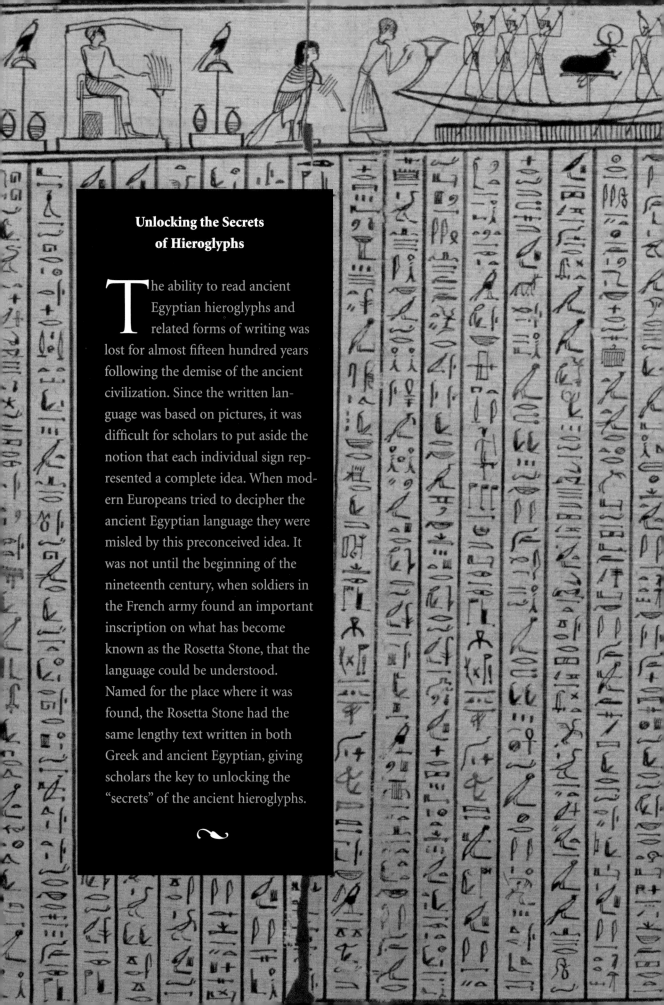

Unlocking the Secrets of Hieroglyphs

The ability to read ancient Egyptian hieroglyphs and related forms of writing was lost for almost fifteen hundred years following the demise of the ancient civilization. Since the written language was based on pictures, it was difficult for scholars to put aside the notion that each individual sign represented a complete idea. When modern Europeans tried to decipher the ancient Egyptian language they were misled by this preconceived idea. It was not until the beginning of the nineteenth century, when soldiers in the French army found an important inscription on what has become known as the Rosetta Stone, that the language could be understood. Named for the place where it was found, the Rosetta Stone had the same lengthy text written in both Greek and ancient Egyptian, giving scholars the key to unlocking the "secrets" of the ancient hieroglyphs.

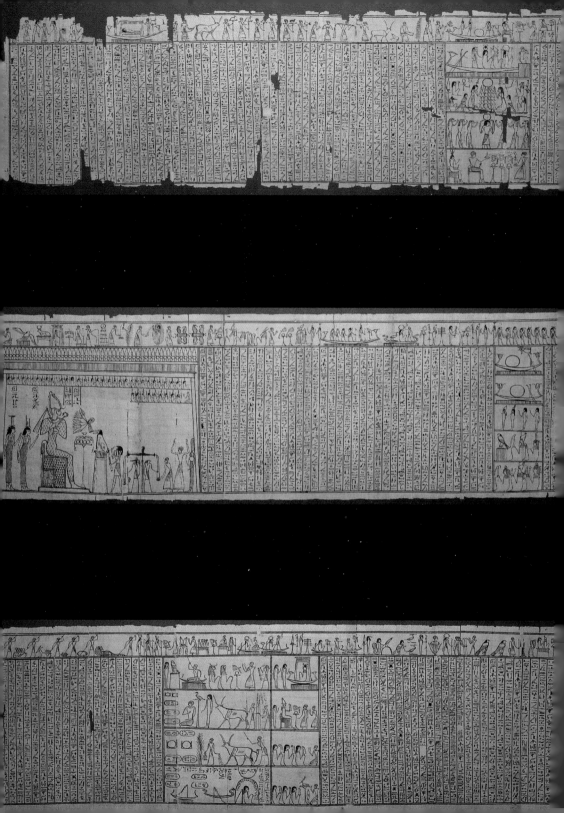

The Book of the Dead of Djed-hor

Ptolemaic Period, 3rd-1st century B.C.
Papyrus and ink; h. 16½ in., total length 141¾ in.
 (42 x 360 cm)
Probably from Akhmim

The Book of the Dead (*left, detail pages 22-23*) was
a collection of prayers and spells for the benefit
of the spirit in the next life. Usually written on
a papyrus scroll, the text could be accompanied
by drawings or paintings. The scroll was placed
in a coffin or tomb with the mummy so that the
deceased would be able to progress through the
underworld, answer challenges, and become one
with the gods. It would enable him or her to
respond to accusations of wrongdoing and freely
communicate with the land of the living.

tion of different uses of the pictures. Some
signs stood for entire ideas, while others were
almost alphabetical in function, conveying
the idea of one, two, or three sounds put
together.

Classic Egyptian signs numbered more
than seven hundred characters, and in the
Ptolemaic Period even this number was aug-
mented by thousands more. Hieroglyphics,
a term taken from the Greek meaning "sacred
carving," were used for formal inscriptions
on tomb and temple walls. Since the drawing
of the many signs necessary for these messages
was time-consuming and tedious, a quicker,
cursive form of writing developed and was
commonly used for texts written on papyrus.
"Hieratic," meaning priestly writing, was the
first cursive style, and it continued to bear
a resemblance to the more formal shapes of
hieroglyphs. The second cursive form, called
"demotic" or popular writing, allowed for
even more rapid writing and became so
abbreviated that it was often difficult to see
its relationship to the original characters.

The abundance of the papyrus plant in
the Nile Valley during ancient times made
it possible for Egyptians to produce the first
paper-like material in world history. In the
Near East, Mesopotamia, and Persia, writing
had developed using wedge-shaped characters
impressed into unwieldy clay tablets. Sheets of
papyrus, however, were light, flexible, easily
stored and transported, and made from read-
ily obtained material. To make the paper-like
sheets, it was necessary to peel the papyrus
stalks and slice the pith into flat strips, which
were then arranged in overlapping patterns
and beaten until they adhered to each other.

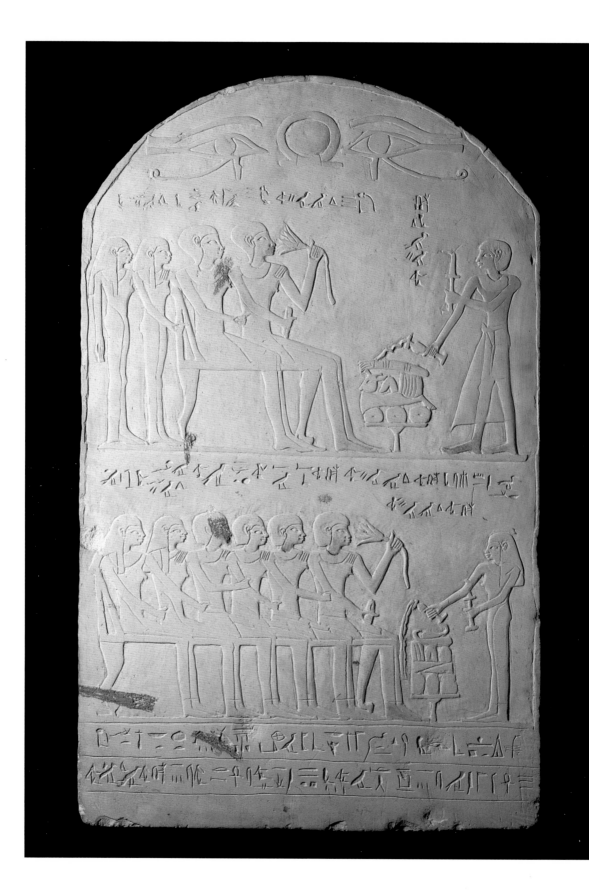

Funerary Stela of the Scribe Kawi

New Kingdom, Dynasty 18, about 1500 B.C.
Limestone; h. 20½ in. (52 cm)
Probably from Abydos

Kawi is shown in the upper register making offerings of food and pure water to his father and three other unnamed individuals. In the lower register, Kawi's daughter, in turn, makes offerings to him. The lines at the bottom contain a customary text asking for the kindness of the king in causing offerings to be made on behalf of the deceased, for the benefit of the spirit.

Fragment of a Tomb Painting

New Kingdom, Dynasty 18, about 1420 B.C.
Mud, plaster, and paint; h. 7½ in. (18.9 cm)
From Thebes

In private tombs of the New Kingdom, the funeral procession and objects to be placed in the tomb were often pictured. In this fragment, the man on the right carries a light two-wheeled chariot and the one on the left carries a chest. In typically Egyptian symbolic fashion, the contents of the chest are pictured on its lid, including a mirror and two vases. The horse-drawn chariot was introduced into Egypt for transportation and warfare during the seventeenth and sixteenth centuries B.C.

The process was completed with a final polishing of the sheets. Pens were made of reed, and the ink was carbon based, probably derived from soot.

The Book of the Dead, a group of texts and spells collected and arranged for the use of the spirit in the next life, is one of the most familiar examples of writing on papyrus. The papyrus scroll for larger examples of the Book of the Dead sometimes measures as long as fifty feet. The number of "chapters" depended on the wishes of the deceased or his family and their ability to pay for the product. There was an industry devoted to the production of these papyrus scrolls, and the quality of them varied considerably. Some examples contained miniature works of art as illustrations. While some scrolls were commissioned, others were obviously made to be purchased on the open market, with the name of the deceased added in the appropriate spaces.

Chips of limestone provided another material for writing, often used to replace papyrus, particularly in Thebes in the south. Flakes of limestone with smooth, flat surfaces were a by-product of quarrying and tomb building and were abundantly available. For a number of uses, such as writing letters, accounts, lists of workmen, and memoranda, these pieces of stone provided a cheap substitute for the more expensive papyrus. These chips were also used as drawing surfaces, literally sketch pads, by Egyptian artists.

URING THE COURSE of its lengthy history, Egyptian society became increasingly complex and bureaucratic. By the time of the Old Kingdom pyramid builders, a highly developed civilization was in place. Ultimate authority rested in the pharaoh, and ranking members of the nobility tended to be from the king's family and household. It was the elite ruling class, which included among its numbers members of the military, high-ranking priests and priestesses, government officials, and diplomats, who bore the responsibility of keeping the complicated society running at a peak level of efficiency. ∾ Advancement in Egyptian

THE NOBILITY

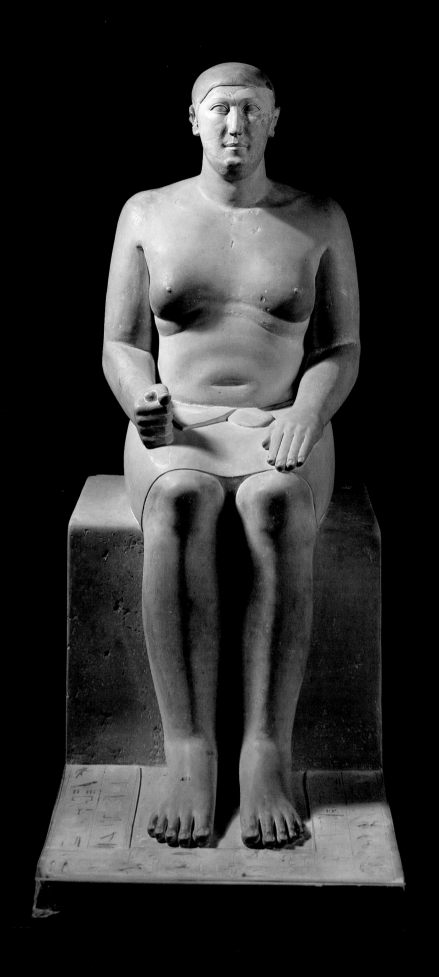

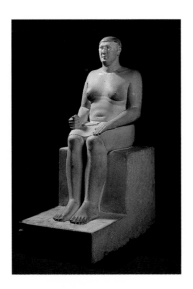

The Vizier Hem-iu-nu

Old Kingdom, Dynasty 4, about 2530 B.C.
Painted limestone; h. 61¼ in. (155.5 cm)
From Giza, mastaba tomb G 4000, excavated by
* Hermann Junker, 1912*

Hem-iu-nu, nephew of the king Khufu (Cheops),
was one of the most important officials in the
country. As vizier—the equivalent of prime min-
ister—he was probably responsible for the build-
ing of the Great Pyramid at Giza. His tomb is one
of the largest in the necropolis, the cemetery or
city of the dead, that grew up around it. He is
depicted here as corpulent, stout, and middle
aged, indicating his importance and authority.

Pepy with Members of Her Family

Old Kingdom, Dynasty 4, about 2300 B.C.
Limestone; h. 17⅜ in. (44 cm)
From Giza, mastaba tomb D 23

In Egyptian art, it was customary for the most
important figure in a group to be the largest. In
this family group, the woman is taller than her
male companion, suggesting her dominant role in
the family. The inscription says only that it is the
woman Pepy with her son, Ra-shepshes. It is possi-
ble that the son is shown both as a child and as an
adult since it was not unusual to have the same
person depicted more than once in a work of art.

society was based to a large extent on family
connections, and while it is clear that the
family of the king held some of the highest
positions of authority, it was still possible for
others to move upward through the ranks of
the military and the priesthood. Such pro-
motion seemed to have been based on real
accomplishment as indicated by the different
titles held by individuals during their lifetimes
as they progressed from lower posts to higher
ones. There were, as well, individuals who
were said to have been recognized by a god
and singled out for appointment to a high
post.

In the four or five hundred years since
the development of writing, occupations
had become highly specialized as reflected
in titles preserved in various documents.
In some cases, titles such as "king's son" or
"king's daughter" attested to a direct rela-
tionship to the ruler. "Priest" or "priestess"

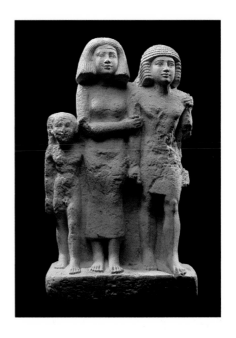

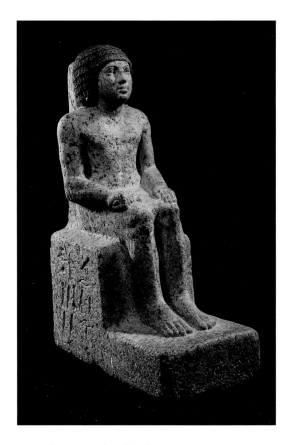

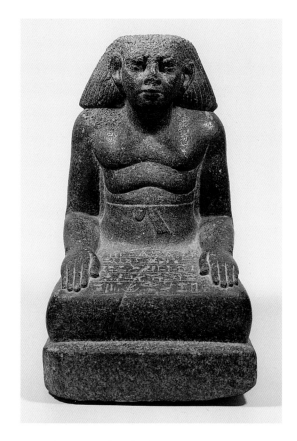

Seated Statue of Nefer-ihi

Old Kingdom, Dynasty 5, about 2360 B.C.
Painted red granite; h. 19½ in. (49.5 cm)
From Giza, mastaba tomb D 208

As the "overseer of the tomb builders," Nefer-ihi
was granted the special privilege of having his
statue carved from granite, a stone usually reserved
at that time for images of royalty. Indications of a
tomb owner's rank and importance can be deter-
mined not only through titles but also from the
quality and quantity of the goods put into the
tomb.

Seated Figure of Sa-hathor

Middle Kingdom, Dynasty 12, about 1880 B.C.
Granodiorite; h. 13¼ in. (33.8 cm)

Sa-hathor was "overseer of the granary for the
divine offerings"; that is, supervisor of food offer-
ings for the gods. He sits with his legs drawn up
under him and wears a shoulder-length wig and
long kilt. His hands are placed on his lap palm
down in a gesture of reverence, suggesting that
this statue was meant to be placed in a temple
to insure the owner's sharing in the rituals and
offerings carried out on behalf of the gods.

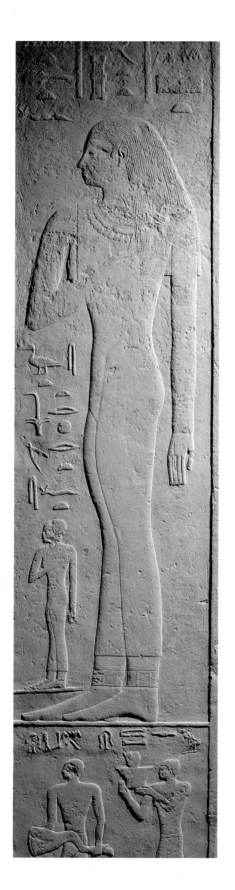

obviously indicated religious responsibilities assumed by individuals who might have other secular duties and titles. A title such as "overseer of the works" identified a supervisor of the building of palaces or temples, while the specific "overseer of the tomb builders" suggests a construction manager of a particular project. "Administrative overseer of the palace workers" was a person conducting the affairs of the household of the king, and a "scribe of the granaries" was an accountant who kept the details of the amounts and kinds of grain in the storehouse. The title

False Door of Princess Wen-shet

Old Kingdom, Dynasty 4, 2460 B.C.
Limestone; h. 87¾ in. (223 cm)
From Giza, mastaba tomb G 4840

Wen-shet was a king's daughter and a priestess of the goddesses Neith and Hathor. Her high rank and position in society allowed her access to the best artists for carving the necessary objects and decoration for her tomb. The false door was a stone imitation of a portal through which the spirit could enter and leave the tomb and partake of food offerings left by priests and pious family members.

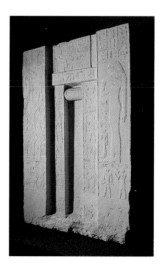

Standing Figure of the Lady Senebi

Middle Kingdom, Dynasty 12, about 1950 B.C.
Painted cedar; h. 12 ⅞ in. (32.7 cm)

Egyptian sculpture was made from stone,
metal, or wood. Often works carved from
wood, such as this statue, exhibit great deli-
cacy and grace. This figure's arms and feet
were fashioned separately and then pegged
into place. Some of the details of the dress
have been carved while others were added
in black paint.

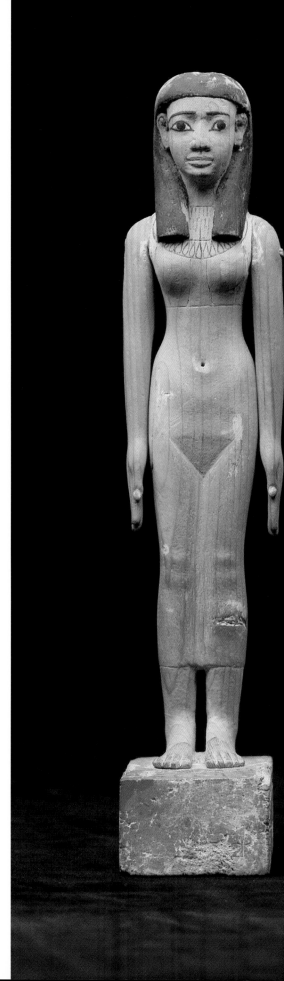

of "scribe" was applied to a variety of posts at a range of levels from the lowly clerk who recorded military recruits to the dignitary who conducted the high-level affairs of the army. In some occupations, titles became highly specialized. For example, among artists who worked in tombs, the rank of "outline draughtsman" denoted one whose skill was of such a high level that he was trusted with some of the finest and most demanding work.

The vast resources required for a project such as the building of a pyramid or a temple testified to the complexity of ancient Egyptian society. Architects, engineers, and construction managers were needed to draw up plans. A site had to be chosen and laid out by trained surveyors. Quarries were selected and the work of gangs of stonecutters had to be supervised. The stone blocks had to be shaped and transported to the building site, demanding enormous crews of laborers, who in turn needed to be supervised and managed. Food and housing had to be provided for the vast number of laborers needed for the lengthy construction period. Considerable evidence exists that temporary villages were built especially for workmen engaged in building projects.

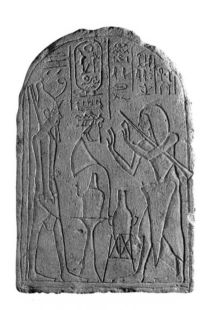

Stela of the Trumpeter Hesi

New Kingdom, Dynasty 19, around 1250 B.C.
Painted limestone; h. 12¾ in. (32.5 cm)
From Qantir

Hesi, with his trumpet under his arm, wears a military kilt and raises his hands in adoration to a statue of the king Ramesses II. The figure on the left is easily recognized as a statue because its upper body is in true profile; that is, with the shoulders depicted as seen from the side and not the front, a convention used for the depiction of inanimate objects rather than a living being.

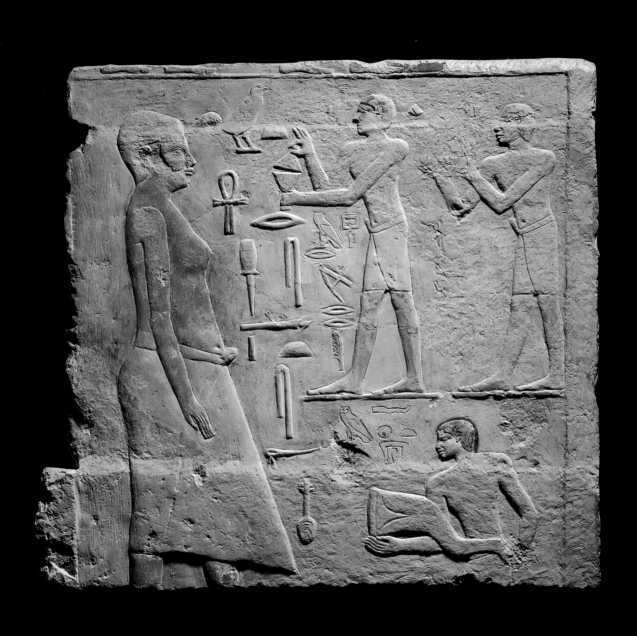

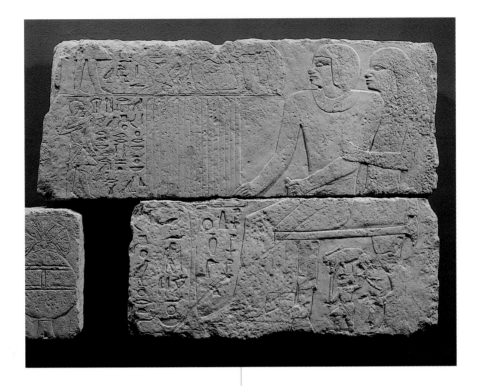

Offerings to a Statue of Sesh-em-nefer IV

Old Kingdom, Dynasty 6, about 2280 B.C.
Painted limestone; 27⅝ x 30¾ in. (70.3 x 78 cm)
From Giza, tomb LG 53

Sculpture placed in tombs, called "ka" statues, were intended to act as alternate dwelling places for the spirit if the deceased's body was damaged or destroyed. This relief (*left*) represents offerings being made to the ka statue of an important official, Sesh-em-nefer. The statue is identifiable as such by its depiction in true profile. The figures in the upper register on the right offer incense and fruit, while the figure partly preserved at the bottom brings forward a haunch of meat.

Offering Relief of Nefer and His Wife

Old Kingdom, Dynasty 6, about 2180 B.C.
Limestone; 29½ x 42⅜ in. (75 x 107.5 cm)
From Giza, mastaba tomb G 5550

In this relief (*above*), the tomb owner and his wife are seated side by side and she embraces him. Beneath their chair are a dwarf and a monkey, images that have been interpreted in the past as representing objects of amusement; however, more recent scholarship suggests that they have a symbolic meaning associated with resurrection.

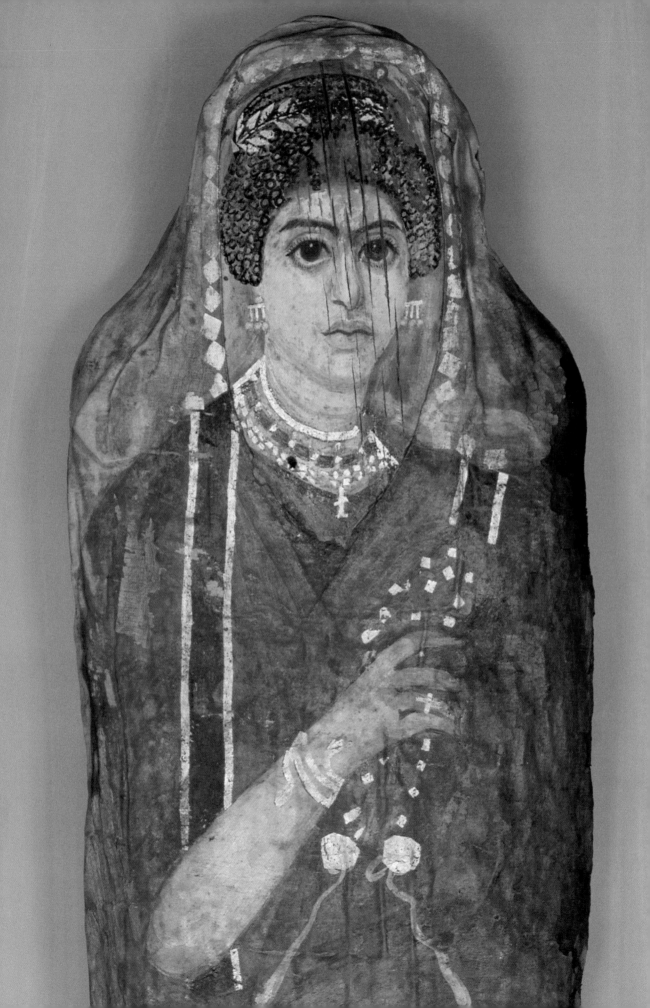

Mummy Portrait and Wrapping

Roman Period, about 100 A.D.

Painted and gilded linen and gesso, with wooden
 panel painted in encaustic; l. 63¾ in. (162 cm)

Probably from the Faiyum region

This portrait from late in Egyptian history depicts
a cosmopolitan member of the ruling elite wear-
ing jewelry typical of the time. The use of gold
and colorful stones for decorative purposes was an
old tradition in Egypt; the snake-shaped bracelets
were popular all over the Mediterranean world.

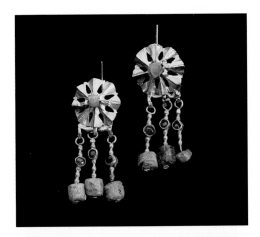

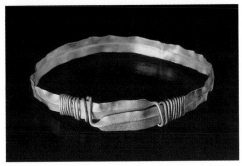

A Pair of Earrings and a Gold Bracelet

Roman Period, 30 B.C.-330 A.D.

Gold, almandine, and beryl; earrings: l. 2 in. (5 cm)
 bracelet: diam. 3 in. (7.5 cm)

These earrings and bracelet date from the end of
ancient Egyptian history. The three-pendant ear-
rings are similar to those in mummy portraits
(*see portrait, left*). The gold bracelet is an interest-
ing leaf-shaped design that seemingly was meant
to be adjustable.

PERSONAL ADORNMENT

A great desire for adornment or embell-
ishment of the face and body was
evident from the earliest times in
Egyptian history. Containers probably used to
hold cosmetics have been found in graves of
the Predynastic Period as have stone palettes
on which minerals were ground to produce
colors for different kinds of eye paint or liner.
In addition, these graves often contained
examples of jewelry such as hairpins, beads,
and pendants. As the resources across Egypt
and of other lands became known and avail-
able, jewelry was produced from gold and
silver and a variety of semiprecious stones.
Turquoise was mined by the Egyptians in the
mountains of the Sinai peninsula, and blue
lapis lazuli was imported from as far away as
present-day Afghanistan. Gemstones such as
diamonds, rubies, and sapphires, however,
were completely unknown to the ancient
Egyptians. Faience, a glazed material similar
to ceramic but made from ground quartzite,
was one of the most popular and versatile
decorative materials. It was made in a variety
of colors, but most often deep blues and greens
were used. Faience was either modeled free-
hand or pressed into a mold and fashioned
into a wide range of decorative objects from
tiny beads and amulets to bowls and plates.

Jewelry, worn by both men and women,
was produced in a number of standard forms
still worn today—bracelets, necklaces, rings,
and earrings—as well as styles more popular
in ancient times, including anklets, armlets
worn on the upper arm rather than the wrist,
broad collars and circlets, and diadems worn

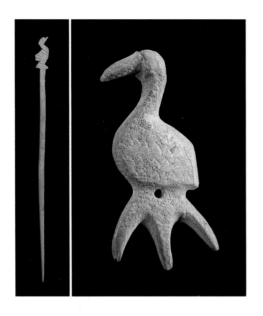

A Hairpin and a Comb

Predynastic Period, before 3200 B.C.
Ivory; hairpin: h. 4¼ in. (10.7 cm) comb: l. 2 in.
* (5 cm)*

Beginning as early as the Predynastic Period, Egyptians were careful of their appearance and took steps to maintain it in the next life by placing grooming aids in burial sites. This comb and hairpin are typical of the cosmetic objects often found in early graves or tombs.

Two Pairs of Earrings

New Kingdom, Dynasty 18, around 1450 B.C.
Gold; diam. 1 in. (2.4 cm)

The desire to enhance and decorate the human body was a constant in Egyptian society. Jewelry of all kinds was made from many materials including shells, semiprecious stones, and precious metals. By far the most luxurious was gold, a metal prized for its incorruptibility. Simple in design, these earrings consist of repeated linear shapes.

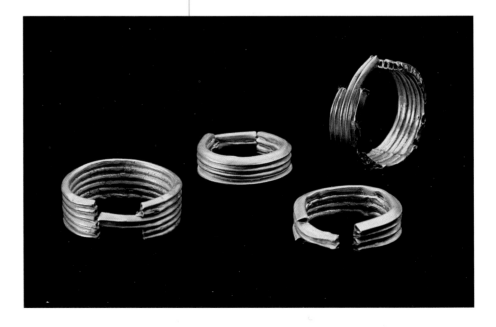

on the head to keep the hair in place. The most elaborate pieces crafted from expensive materials were reserved for the nobility. A combination of gold or silver wire and colored beads was often used in the creation of bracelets, and the placement of cut and polished bits of colored stone in a gold framework was not uncommon. There was a great reliance on plant and flower forms as well as hieroglyphic signs for the formulation of decorative motifs and elements.

In addition to jewelry and cosmetics, personal adornment often included extensive use of wigs. Elaborately styled wigs probably served as a status symbol. Female wigs were depicted on some statues, where the representations of both the real and the artificial hair were clearly differentiated. False beards were an emblem of kingship and were restricted to royal use. Gods also had false beards because of their importance. Usually the god's beard turns up at the end.

Mirror

New Kingdom, Dynasty 18, around 1420 B.C.
Bronze; h. 9⅝ in. (24.5 cm)

Cosmetic objects in ancient Egypt were often exquisitely crafted, as is this mirror shaped to suggest the sun or moon and thus the cycle of birth and death. The handle resembles a column with an image of the goddess Hathor, a powerful symbol of protection, as its capital. The considerable attention to the symbolic design of such items made them an important addition to tomb objects for use in the next life.

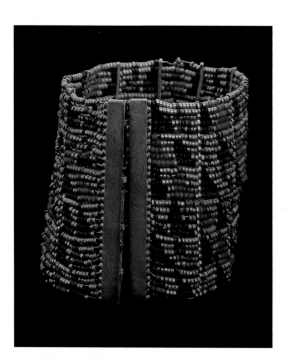

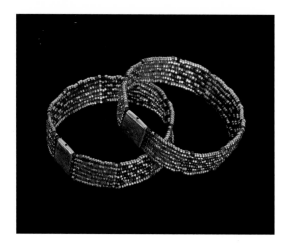

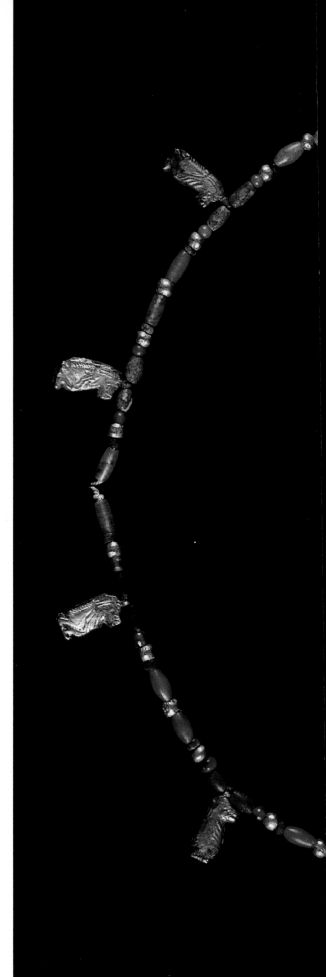

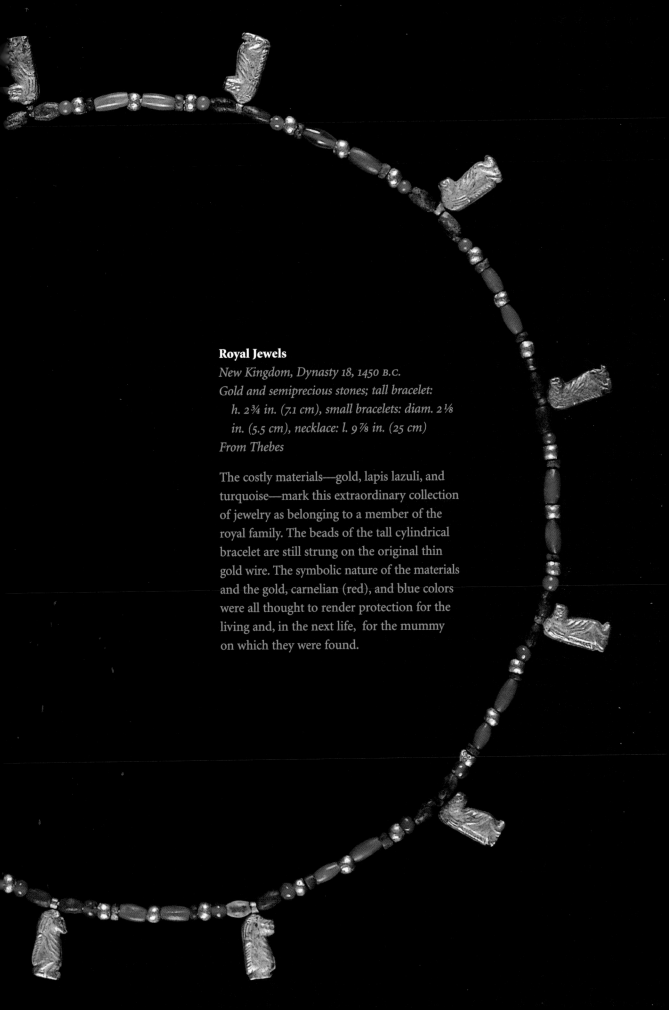

Royal Jewels
New Kingdom, Dynasty 18, 1450 B.C.
Gold and semiprecious stones; tall bracelet:
 h. 2¾ in. (7.1 cm), small bracelets: diam. 2⅛
 in. (5.5 cm), necklace: l. 9⅞ in. (25 cm)
From Thebes

The costly materials—gold, lapis lazuli, and
turquoise—mark this extraordinary collection
of jewelry as belonging to a member of the
royal family. The beads of the tall cylindrical
bracelet are still strung on the original thin
gold wire. The symbolic nature of the materials
and the gold, carnelian (red), and blue colors
were all thought to render protection for the
living and, in the next life, for the mummy
on which they were found.

Offering Relief of Iunu

Old Kingdom, Dynasty 4, about 2540 B.C.
Painted limestone; 15 ⅜ x 21 ¼ in. (39 x 54 cm)
From Giza, mastaba tomb G 4150

This beautifully carved limestone relief depicts the high official Iunu, one hand clasped to his breast, the other extended toward a table where stylized loaves of bread are arranged. Iunu wears a long white garment and is seated on a stool with animal-shaped legs. Above the table are a pitcher and cuts of meat along with a list of offerings to Iunu: incense, oil, figs, and wine. Below are abbreviated hieroglyphs for thousands of additional offerings of linen cloth, alabaster jars, bread, and beer. The grid on the right contains a list of various quantities of linen cloth. The subtlety of its execution ranks this relief as one of the great masterpieces of its kind in the history of Egyptian art.

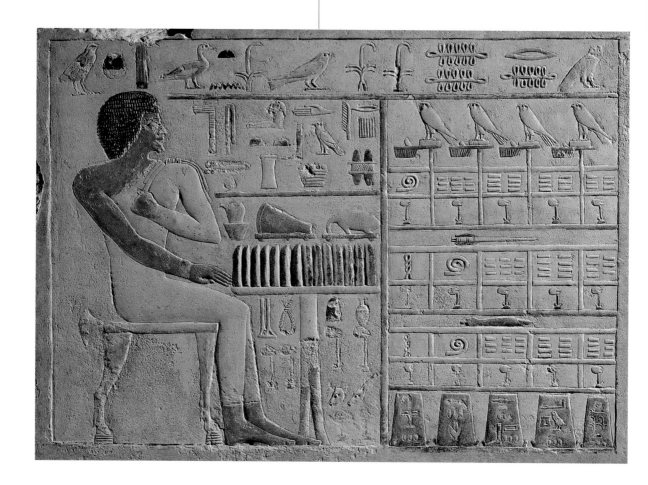

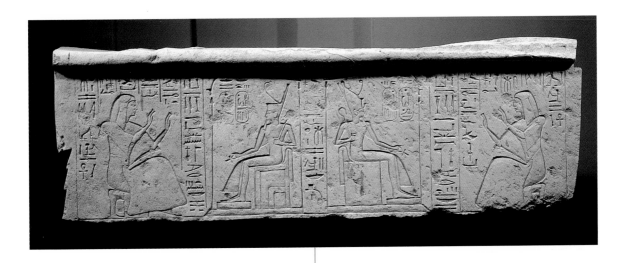

Lintel from a Chapel Dedicated to Ramesses II

New Kingdom, Dynasty 19, 1307-1196 B.C.
Limestone; l. 52 in. (132 cm)
From Qantir

Ramesses-mery-seti, one of the many sons of the ruler Ramesses II, dedicated a chapel to his father. This relief comes from the top of the structure's door. The Egyptian love for symmetry allowed the king to be shown twice in the center, on the left wearing the red crown of Lower Egypt and on the right, the white crown of Upper Egypt.

ART

There was very little place in Egyptian culture and society for the concept of "art for art's sake," the appreciation of works of art based solely on aesthetic value. The art of ancient Egypt can be considered a shorthand composed of symbols, with nearly every work having a religious or political meaning (often the same thing). The idea that an artist might create a portrait representing a particular person, noble, or king, simply for the viewer's enjoyment, was totally unknown. The symbolic presentations favored by the Egyptians include many stylistic conventions that may seem strange to modern eyes, particularly the use of composite views—the combining of multiple vantage points, such as frontal and profile renderings—into a single form.

Depictions of the human form provide an excellent example of such a composition. The Egyptian artist chose the most recognizable view of a body part, the one easiest to visualize and to portray. Typically, an image

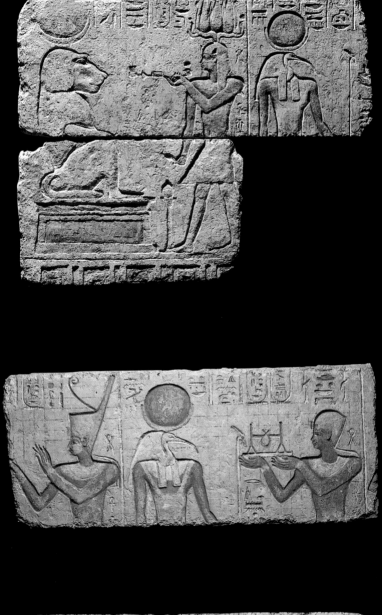
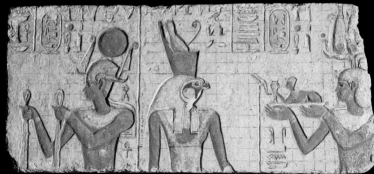

of a standing man showed the head in profile, that is from the side, with the shoulders facing front, and the lower body, legs, and feet again seen from the side. Within the profiled face, the eye was positioned as viewed from the front. When combined, these various views form a total image that seems, to the modern viewer, somewhat stiff and awkward. The artist's intention, however, was not to create a realistic, pleasing picture from some particular moment in time, but rather to devise a timeless symbol for an idealized representation of an individual.

Similar composite conventions applied to the depiction of inanimate objects as well. In the image of a game board, for instance, the board itself was shown as from above, so that all the squares were clearly visible. The pieces, or markers, however, were drawn as seen from the side because the profile was the shape most associated with the object and the most easily recognizable. The two views were combined and understood as a representation of the idea of a board with game pieces. The contents of chests or boxes were often shown as if standing on the top of the container but were meant to be understood as the objects that were inside.

Other important artistic rules, which were developed very early in Egyptian history, governed the scale, color, and placement of figures in relationship to one another. The size of an image was generally in direct proportion to the importance of the individual or object depicted. Thus a god was the largest, followed by the king, members of the nobility, commoners, and animals, in that order. The more important a person, the more his or

Reliefs from the Chapel of Thoth

Ptolemaic Period, about 295 B.C.
Painted limestone; average h. of blocks 17¾ in. (45 cm)
From Tuna el-Gebel

Ptolemy I, the founder of the last dynasty (Ptolemaic) before the Roman conquest, is shown making an offering to Thoth, the god of wisdom, who appears as a seated baboon in the top panel and as an ibis-headed figure in the middle one. In the lower panel, the ruler is making an offering to the falcon-headed Sokaris, a god of the necropolis. The red grid squares laid out to guide the artist in painting the composition are still visible. The panels were originally arranged along the wall of the chapel dedicated to Thoth.

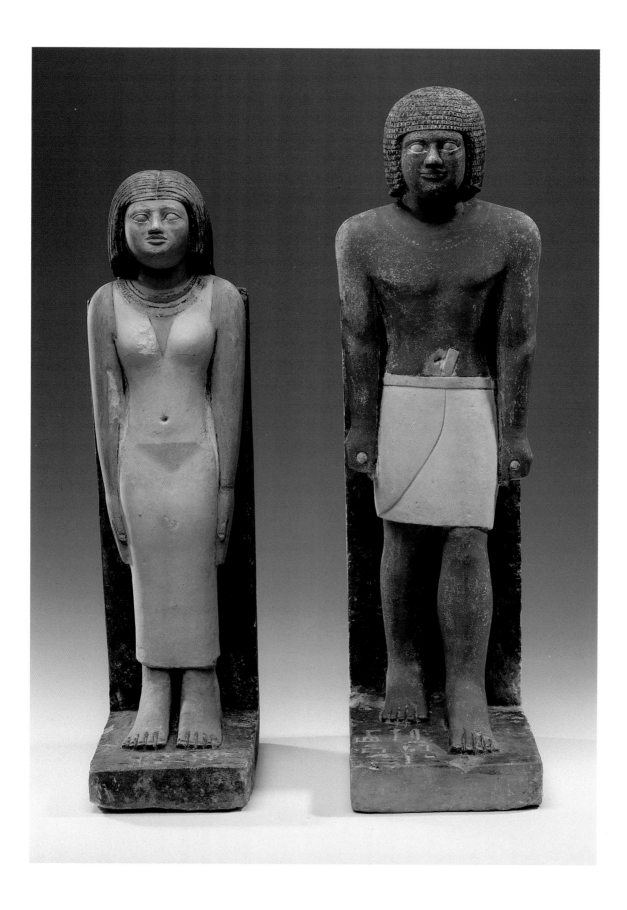

her image had to follow the prescribed rules of representation so that workmen in the fields could be shown in a less strict, more informal manner than overseers or landowners. The skin color of men was normally a red or red-brown and that of women yellow, a convention thought to have been intended as a means of broadly showing the difference between the indoor and outdoor occupations of the two sexes. There was little attempt to suggest depth in wall paintings or carving. Often people shown as if they were walking or standing one behind the other are actually meant to be understood as standing side by side. This is particularly true of images of husband and wife, where the couple was certainly meant to be visualized in such a manner.

Similar conventions ruled the creation of three-dimensional sculpture, for the intention, as with painting, was to make a symbolic representation that would last, it was hoped, forever. To this end, the Egyptians carved figures that stand and sit erect, look straight ahead, and do not show any sign of emotion. Standing figures of men have their left foot forward, arms at their sides, and fists clenched. Generally, women were shown with their feet together and their hands open. ❧

Funerary Statues of Iru-ka-ptah and His Wife

Old Kingdom, Dynasty 6, around 2250 B.C.
Painted limestone; h. 23 ⅝ in. (60.1 cm) and 21⅛ in.
 (53.6 cm), respectively
From Giza, mastaba tomb D 61

These ka statues of a husband and wife show the different standards for representing men and women in ancient Egypt. The man stands with hands clasped at his sides, left foot advanced, and looking straight ahead, while the woman holds her open hands at her sides with her feet together, but also looking ahead. Dark red-brown was the usual skin color for males, who were active in the open sun; yellow was the color for females, who spent most of their time indoors. As ka statues, these figures were placed in a closed chamber in the tomb, where they were to serve as alternative resting places for their spirits and the focus for offerings made to them.

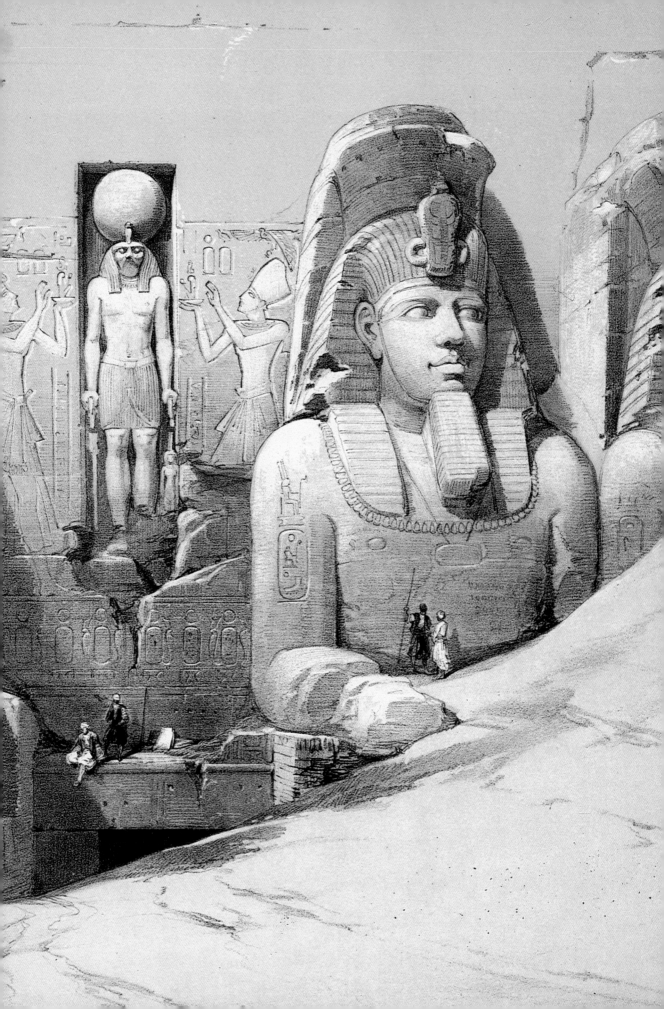

THE ANCIENT EGYPTIANS held complicated beliefs about their rulers. If they did not believe that their king was divine—a god on earth—they certainly regarded him as the representative of the gods, whose right to rule came from them, and who was responsible for the well-being of Egypt and all humanity. The king served as an intermediary between the people and the gods. In all time periods, the ruler was shown, in reliefs and paintings, making offerings to the gods as a means of appeasing them and preserving the order, not only of the state but also of the universe. In some temples and chapels, the image of the king was depicted again and

RULERS

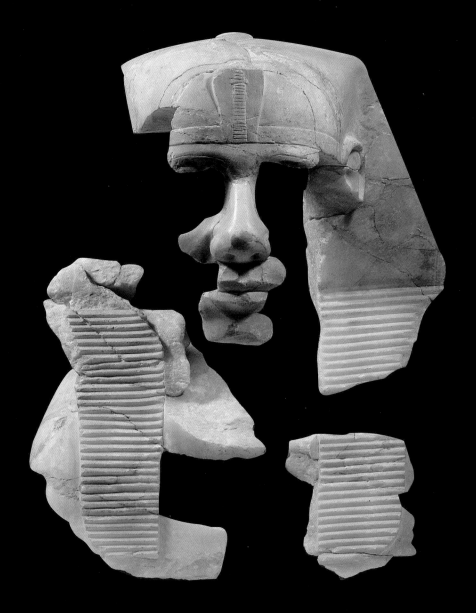

Head of Khafre (Chephren)

Old Kingdom, Dynasty 4, about 2500 B.C.
Painted alabaster; h. 19⅛ in. (48.7 cm)
From the Mortuary Temple of Khafre at Giza

In the Old Kingdom, the representation of the reigning king was intended to convey his godlike perfection, timeless and ideal. This head still very much suggests its original beauty, despite the fact it has been reassembled from fragments found in the excavation of the king's Mortuary Temple. Khafre was the ruler for whom the second pyra-

mid on the Giza plateau was constructed, and it is probable that the Great Sphinx was carved in his image. Although many statues were made for the king, most were destroyed and the valuable stone was reused for other purposes, perhaps carved into utilitarian objects such as containers and headrests.

**Fragmentary Head of Senwesret III
(Sesostris III)**

*Middle Kingdom, Dynasty 12, about 1850 B.C.
Quartzite; h. 9⅝ in. (24.3 cm)*

In contrast to the idealized perfection of Old
Kingdom royal portraits, the images of Middle
Kingdom rulers such as this one of Senwesret III
exhibit more human attributes—care, worry, and
perhaps even fatigue. This remarkable fragment of
a great sculptural masterpiece clearly shows this
attention to expression in the modeling of the
head, the deep-set, heavy-lidded eyes, and the
slight trace of wrinkles on the badly preserved
cheeks.

again, as if, by the very repetition of these
acts of offering, the ruler's devotion was
intensified and made more potent.

The living king was always identified with
the god Horus, the son of Osiris, god of the
dead and resurrection. When the king died,
he became Osiris, and the son who succeed-
ed him on the throne became the "living
Horus." The role of women in governance
was usually restricted to acting as a regent
for an underage son, but in rare instances
the queen actually ruled the country. Queen
Hatshepsut, a prominent example from the
New Kingdom, first acted as regent for her
nephew Tutmosis III but then assumed the
rank and title of king and had herself por-
trayed in works of art as a male ruler wearing
men's regalia and costume.

Every king had several names and titles,
each with a special function. A standard title
was the "Horus Name," which proclaimed
the ruler as the living manifestation of the
god. The title "king of Upper and Lower
Egypt" was a remembrance of the time when
the land was not united. Other names includ-
ed the prenomen or "throne name," given at
the time a ruler was crowned, and the nomen,
a personal name sometimes used like a family
name. When written in hieroglyphics, these
names were enclosed in a cartouche, the
often round or oval-shaped area used to set
inscriptions off from the text. The cartouche,
formed by a tied rope that was seen as endless,
had a symbolic meaning of eternal life.

In addition to holding political power, the
king was the chief priest, bearing the responsi-
bility for creating and preserving the structure
of religion. In that capacity, a ruler was credited

Relief from a Temple of Akhenaten

New Kingdom, Dynasty 18, about 1350 B.C.
Sandstone; 6¼ x 10⅝ in. (16 x 27 cm)
From Karnak, Thebes

Akhenaten is shown here wearing the red crown
of Lower Egypt while being blessed and protected
by the rays of the sun disk, representing his god,
the Aton. Akhenaten, the son of Amenhotep III,
espoused a new religious order dedicated to one
god and the denial of the many ancient Egyptian
gods. His reign was a troubled one and, after his
eighteen-year rule, the country returned to its
traditional religion.

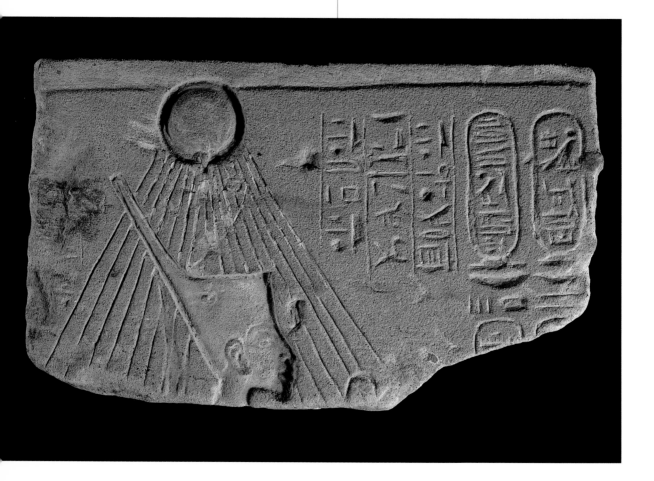

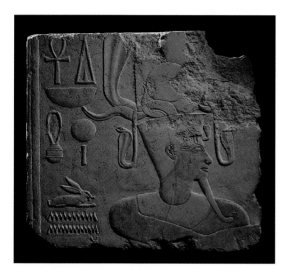

The Deified King Tuthmosis I

New Kingdom, Dynasty 18, about 1465 B.C.
Painted limestone; h. 16⅛ in. (41 cm)
From Western Thebes, Deir-el-Bahri, Temple of
* Queen Hatshepsut*

This idealized image is in the classic style of the highest quality carving known from ancient Egypt, characterized by the almond-shaped eye, aquiline nose, thin lips, and slightly protruding chin. The complex headdress consists of standing double plumes, pairs of horns from a ram and a bull, two large rearing cobras, two smaller pendant cobras, and a fifth cobra, the uraeus or symbol of royal authority, at the brow. The long beard, curved at the end, identifies this as an image of a king who has become a god after his death.

Amenhotep III and Queen Tiye

New Kingdom, Dynasty 18, about 1350 B.C.
Ebony and traces of gilding; h. 2¼ in (5.8 cm)
* and 2½ in. (6.4 cm), respectively*
From Medinet Gurob

These two small figures are unusual for their size and the material from which they are carved—wood—which was not commonly used for royal images. Evidence of dowel rods in the undersides of the figures indicate they were once affixed to some other object. It is possible these were images placed at the tops of ceremonial staffs or standards.

for having "built" a temple. After a particularly disruptive period in Egyptian history, a king might state in an inscription that he had found the temples in disarray and had them repaired and restored, just as he had reestablished Ma'at— order, truth, and right-doing— to the land.

The obligation to preserve Ma'at included protecting the land of Egypt from foreigners, and on the walls of many temples the king was shown defeating the enemy in battle. These vivid depictions were not always accurate records, however, since not all kings were actually warriors. Although these images did record real military conquests, they also had symbolic value, displaying the victory of the king over the agents of chaos who would disrupt the order of the land and the universe.

There were more than two hundred rulers of ancient Egypt, only a small number of whom are familiar names today—for example, Khufu, also called Cheops; Akhenaten, Tutankhamun, Ramesses II, and Cleopatra. In some cases, very little is known about a king's reign; in others, the ruler is remembered for things such as the size of his monuments

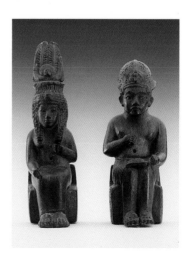

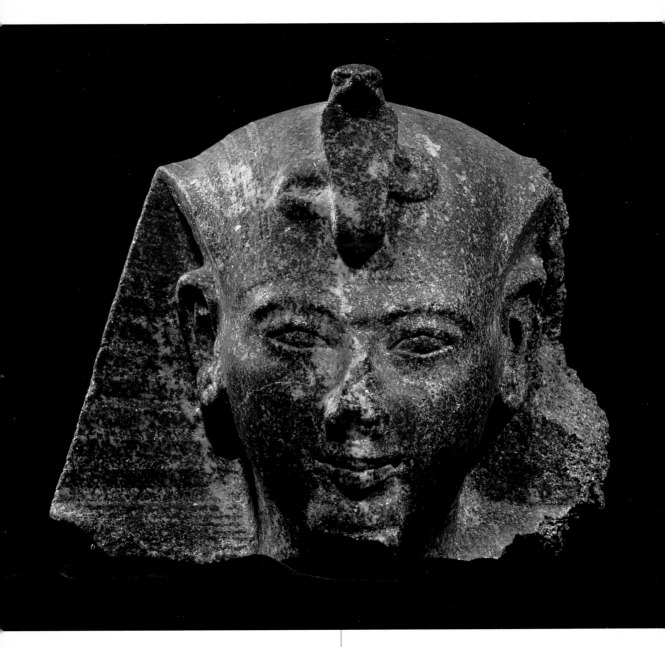

Head of Ramesses II
New Kingdom, Dynasty 19, about 1280 B.C.
Granite; h. 9½ in. (24.3 cm)
Probably from Thebes

This royal head, with the symbolic cobra of
authority at the brow, has been identified as
Ramesses II, one of the longest reigning and
greatest rulers of ancient Egypt. It is an ideal
representation of the king, depicting him as
a perfect being.

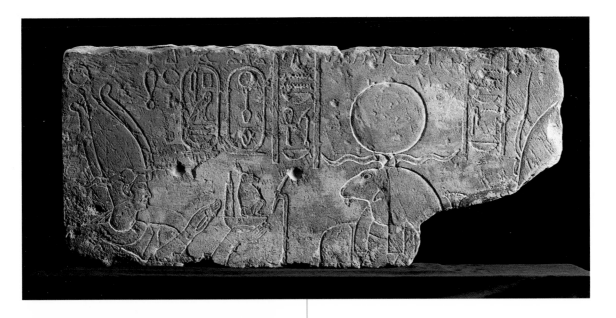

Psametik II Offering to the God Khnum

Late Period, Dynasty 26, about 590 B.C.
Sandstone; 15 ½ x 35 ¾ in. (39.4 x 90.8 cm)

On this relief, King Psametik is shown, at the left, making an offering to the ram-headed god Khnum, on the right. Behind Khnum is his daughter, the goddess Satis. Khnum was the patron deity of the first cataract of the Nile in the region of modern Aswan.

Not always a pharaoh . . .

The rulers of Egypt were not always called "pharaoh," a title that comes from the ancient Egyptian words *Per-aa,* meaning "great house." The term was not applied to the king until well into the New Kingdom, in about 1200 B.C. to 1000 B.C. It was used to designate the ruler in much the same way as the "White House" has come to stand for the president of the United States. In modern times, all kings of ancient Egypt are often called "pharaoh," and the time in which they ruled "pharaonic," even if their reign was early in Egyptian history, before the title came into use.

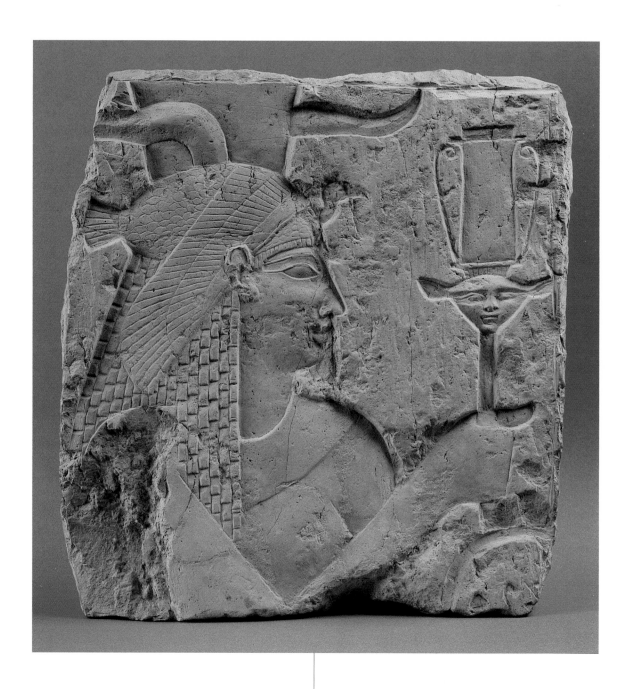

Queen Arsinoe II

Ptolemaic Period, 300-100 B.C.
Limestone; h. 11⅝ in. (29.5 cm)

This compelling relief depicts one of the great queens of the Ptolemaic Dynasty, Arsinoe II, a strong-minded and influential ruler who shared the throne with her brother, whom she later married, Ptolemy II. She is shown shaking a sistrum, or rattle, topped with an image of the cow-headed goddess Hathor, in an act of devotion to the gods. She wears the vulture headdress of queens, and the remains of a crown and the horns of a ram, sacred to the god Amun, can be seen above it.

that tell little about his regime. Almost nothing is known about the reign of Khufu (2551 B.C.-2528 B.C.), beyond the fact that the Great Pyramid at Giza was built as his tomb. He must have been one of the great rulers of the country, but only one small statue of him has been preserved. Akhenaten (1353 B.C.-1335 B.C.), living more than a thousand years later, attempted to institute the cult of a single sun god. He rewrote the rules of Egyptian art, but after his disappearance (it is not known what happened to him), the Egyptians tried to erase any memory of his reign. Tutankhamun (1333 B.C.-1323 B.C.) was Akhenaten's son-in-law and ruled for a short time after him. A relatively unimportant king with little if any great accomplishments, Tutankhamun is well known because his tomb was discovered preserved in nearly perfect condition. By contrast, Ramesses II (1290 B.C.-1224 B.C.), also called Ramesses the Great, had one of the longest reigns in Egyptian history, fought great battles, built temples from one end of Egypt to the other, and carved out his own place in history. The famous Cleopatra was actually the seventh queen to bear that name. Her family dynasty, founded by Ptolemy, Alexander the Great's general, ruled for almost three hundred years. Cleopatra was the last of the Ptolemies. Her attempt to preserve the independence of her country against the forces of Rome and her personal relationships with Julius Caesar and Mark Antony have become the basis of both history and legend. ❧

Ptolemy II Offering to the Goddess Isis

Ptolemaic Period, 332-30 B.C.
Granite; 45 ¼ x 66 ⅞ in. (115 x 170 cm)
From the Temple of Isis at Behbit el-Hagar

After the conquest of Egypt by Alexander the Great in 332 B.C. and his subsequent death, Ptolemy, one of his greatest generals, founded his own family line to rule the country. The Ptolemies, although Greek in origin, continued to honor Egyptian traditions and religion. They had themselves represented as pharaohs in Egyptian garb and regalia. This relief depicts Ptolemy II twice, making an offering to the goddess Isis.

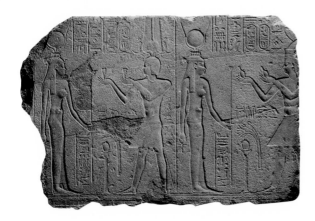

ANCIENT EGYPTIAN BELIEFS about religion, gods, creation, and the order of the universe changed and developed over the course of the country's three-thousand-year history. The Egyptians venerated a great number of gods, who took on a variety of forms and meanings, and they saw in the forces of nature the powers usually associated with deities. Thus the sun and the moon, the sky and the earth, and even the spirit of a particular place could be characterized as a god or goddess. In addition, the Egyptians' reluctance to change anything honored by their ancestors made it impossible for them to discard outmoded beliefs, and any new ideas were simply grafted onto

GODS & GODDESSES

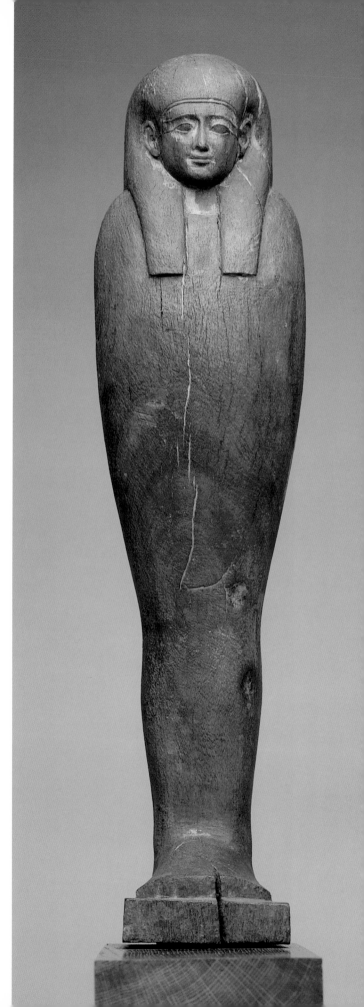

A Ba-bird and Ptah-sokar-osiris

Late Period, 6th-4th centuries B.C.
Wood, gesso, and gilding; Ba-bird: h. 9 in.
(23 cm), Ptah-sokar-osiris: h. 21 ⅝ in. (55 cm)
From Middle Egypt

In the twilight of ancient Egyptian history, it became increasingly common to combine the attributes of various deities into one entity such as this mummy-form figure (*right*). This complex god has assumed the attributes and identities of three others—Ptah, Sokaris, and Osiris—bringing together in a composite deity the concepts of creation, death, and the afterlife. The ba (*above*), usually depicted as a human-headed bird, was one of the powers that allowed the spirit to leave the body and move freely in the afterlife.

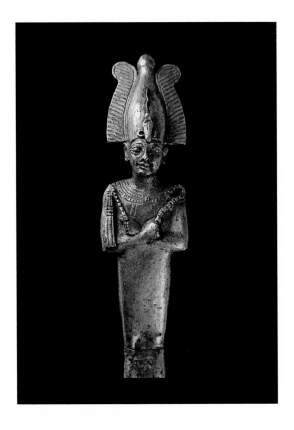

Statuette of the God Osiris

Late Period, Dynasty 25/26, about 680 B.C.
Gilded silver; h. 3⅜ in. (8.7 cm)

One way of venerating a deity was to wear an
image of the god as a form of personal decora-
tion. This small figure of Osiris, the principal
deity of the next life, would have been placed on
a cord or chain. Osiris is shown with a false beard
and the atef crown usually associated with him.
He is holding signs of kingship—the crook, sym-
bol of the shepherd, and the flail, an instrument
for threshing grain.

the old ones, making it hard to generalize
about their theology.

Furthering the confusion, the Egyptians
were willing to accept more than a single
explanation for important concepts, such as
the creation of the world, which was recounted
by several myths. There was general agreement,
however, that the sun god was in some way
responsible for creation, which was accom-
plished through magic, and that the site
of creation was a mound of earth, often
described as emerging from the waters of
chaos. The creator god's establishment of
order in the universe and separation of it
from the surrounding chaos was not viewed
as a one-time event but was believed to be
reenacted every morning with the rising of
the sun. The Egyptians believed it was neces-
sary to assist in the preservation of the uni-
versal order by personal adherence to ideals
of reverence, humility, and restraint. The
king, as the agent through which humanity
related to the gods, was held personally
responsible for the people's devotion to the
deities, and, consequently, for public order.

In one version of the creation story, the
sun god Atum made the god Shu (air and
light) and the goddess Tefnut (heat and
moisture). They, in turn, produced the god
Geb (the earth) and the goddess Nut (the sky),
who then brought forth the gods Osiris and
Seth and the goddesses Isis and Nephthys.
These last four were to be the principal actors
in one of the most important of Egyptian
myths, in which Osiris was restored to life
and became immortal. After the creation,
Osiris was given dominion, or kingship, over
the land. He ruled with justice and maintained

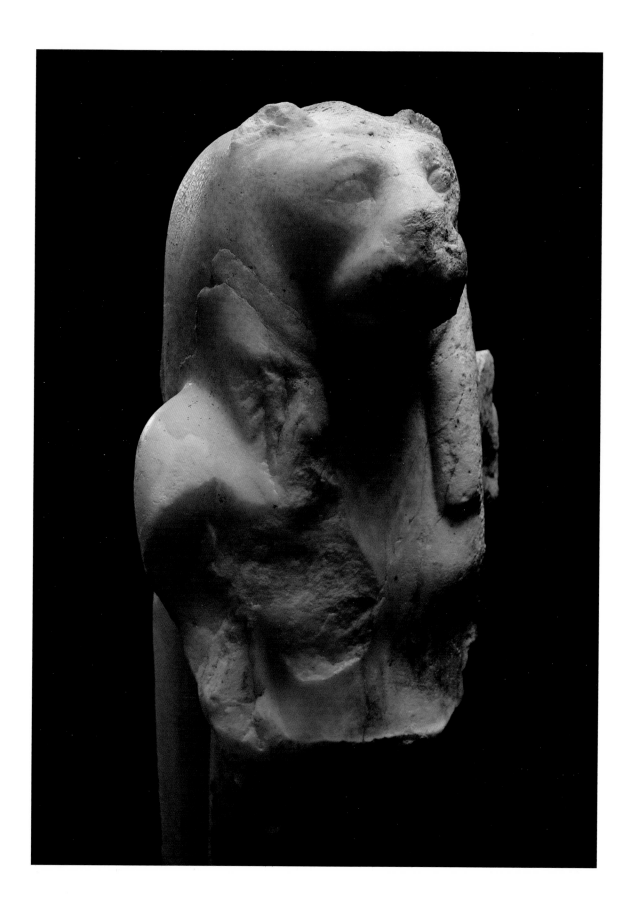

The Goddess Bastet

Old Kingdom, Dynasty 4, about 2500 B.C.
Alabaster; h. 17¾ in. (45 cm)

This rare example of animal sculpture (*left*) dating from the Old Kingdom is a representation of the goddess Bastet, the patron deity of the city of Bubastis. The manner in which the work was broken along one side indicates it was once a part of a larger composition depicting a king in the company and protection of the goddess.

The Sacred Cat of Bastet

Late or Ptolemaic Period, 663–30 B.C.
Bronze; h. 5¾ in. (14.5 cm)

The sacred cat (*below*) associated with the goddess Bastet is perhaps the most familiar animal image from ancient Egypt. Elegant in their graceful stance, such statuettes were votive images to the goddess and sometimes were used as coffins for mummified cats.

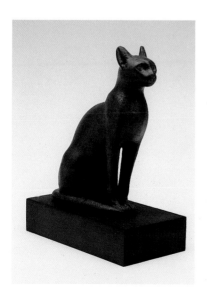

order, but his brother Seth was jealous and murdered him. Osiris's wife, Isis, used magical means to bring him back to life. He then became the principal god of the afterlife. A dispute over rulership ensued between Horus, the son of Osiris and Isis, and his uncle Seth, with Horus emerging as victor and asserting his right to follow his father on the throne of Egypt.

The stories of Osiris's death and resurrection, and of the combat between Horus and Seth, were told with many variations. For example, in one version, Osiris drowned in the Nile, while in another his body was cut up into many pieces and distributed throughout the land. In all the various versions, it is through the help of Isis and her sister, Nephthys, that it was possible for Osiris to achieve immortality. Nowhere in Egyptian texts or literature is there a complete account of the myth, and it is only through the attempts of some Greek and Roman authors that the whole story was put in order.

The myth of Osiris, who was able to gain eternal life by the grace of the sun god Re, was central to the practices of preparation for burial and the belief in the possibility of life after death in another world. It was also of vital importance to the orderly transition of power from the deceased king to his son. The new king was likened to the young, living Horus with the dead father considered to have entered the next life as Osiris.

A number of gods and goddesses had distinct characters and functions, although they could take on different meanings depending on locality, tradition, usage, and situation. For example, Atum, Re, Horus, the Aton, and

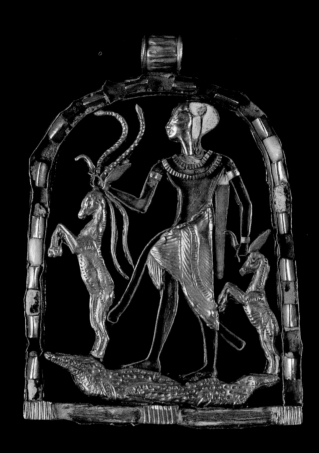

A Pectoral with an Image of the God Shed

New Kingdom, Dynasty 18/19, about 1300 B.C.
Gold with colored inlays; h. 2 ¾ in. (6.9 cm)

The god Shed, "he who rescues," was an important
force for personal protection against dangers of all
kinds, including magic and illness. Shed is usually
depicted as a young prince, wearing the side-lock
hairstyle associated with children, a beaded collar,
kilt, and an arrow quiver slung over his shoulder.
He stands on two crocodiles and holds wild animals
and serpents in his hands. Most of the colorful inlay
has been lost on this piece, but the god's figure
would have been finished with red carnelian.

others were all considered sun gods at one time or another. Hathor was the goddess of women in some places but in others was considered a sky goddess or perhaps a tree goddess. There was no shortage of variations as to how individual deities might be imagined and represented: Hathor's motherly qualities were expressed through association with her sacred animal, the cow, but she could be depicted as completely human with cow ears, with the head of a cow, or as the whole animal.

Many of the gods were associated with one or more specific animals, which provides an aid to recognizing particular deities. Thoth, the patron of scribes and the messenger of the gods, was often depicted with the head of an ibis. But the baboon was also sacred to him, and he was depicted as that animal as well. Amun, the great state god of Egypt, was almost always shown as completely human in appearance but was associated with both the ram and the goose. He is easily recognized, however, by his headdress, which included tall plumes.

Pyramidion of the Scribe Moses
New Kingdom, Dynasty 19, about 1250 B.C.
Limestone; h. 21 in. (53.3 cm)
Probably from Thebes

This small stone pyramid, called a pyramidion, was the cap stone for a brick monument built over a tomb cut into the rock. The deceased is depicted on one side in a pose of adoration. The object of his reverence is the sun god Re, represented on the opposite face by the sun on the horizon. On the two flanking sides are baboons, who also worship the rising sun. The belief that the animals are greeting the sun is based on the observation that baboons screech at sunrise.

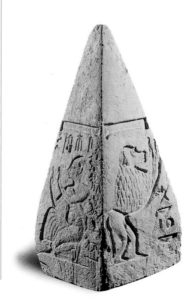

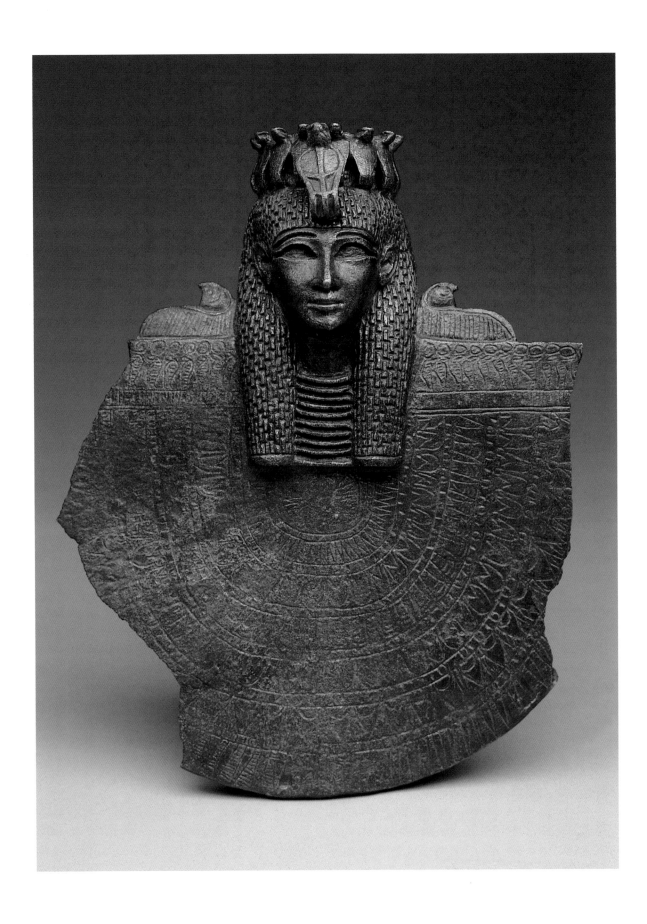

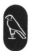

The God Bes

Ptolemaic Period, 332-30 B.C.
Limestone; h. 18¼ in. (46.5 cm)

The god Bes (*right*) was traditionally represented as a dwarf god with lion-headed features. He wears a panther skin as a cape over his shoulders and on his head he would have had a headdress of tall feathers. Bes was a powerful protector of mothers and children and was also considered a patron of the household and of children's games.

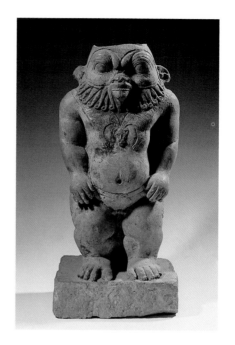

Ceremonial Shield (Aegis)

Late Period, Dynasty 26-30, 600-300 B.C.
Bronze; h. 8¾ in. (22.3 cm)

This type of object, a broad beaded collar surmounted by the head of a goddess (*left*), is often depicted as being held by goddesses or used as an ornament on the prow of sacred boats. The goddess above the collar, who has no definite indication of identity, could represent any of three mother deities—Mut, Isis, or Hathor. Her eyes and eyebrows were once inlaid with colored stone, which, when combined with the crown of cobras, would have made a stunning total effect.

Animals were not worshipped, except as a manifestation of a particular god. Cats, for example, were the sacred animal of Bastet, the patron goddess of the city of Bubastis in the eastern Nile Delta. Animal attributes were selected to suggest the powers or personalities of the gods. Sakhmet, the protectress of Egypt and avenger for the sun god Re, had a destructive side to her nature and was depicted as a lion-headed entity, one of more than thirty deities represented by that animal. Some of the gods shared similar qualities and now can only be recognized and differentiated from one another with the help of an identifying text. This is particularly true of figures such as Isis and Hathor, who, in their human representations, are indistinguishable.

Some gods and goddesses were originally patron deities of provinces or cities but then became more widely accepted, although regional variations in worship continued to

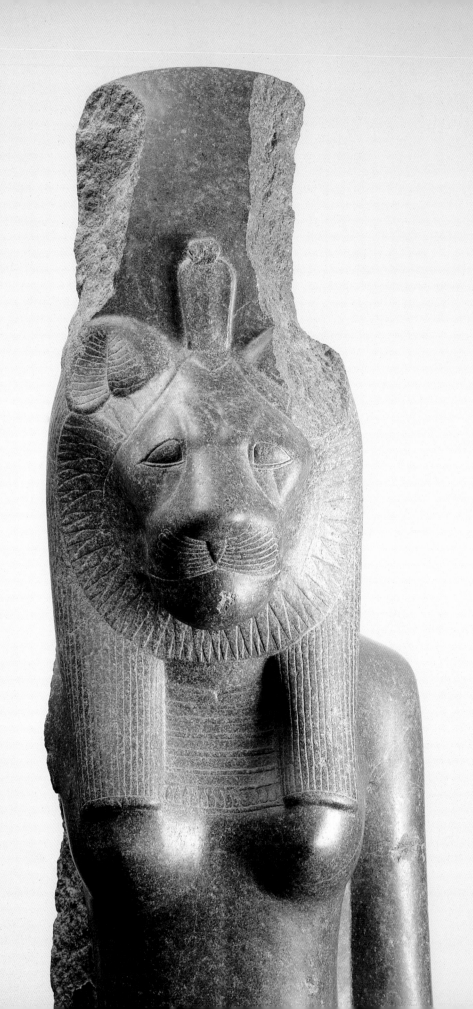

The Goddess Sakhmet

New Kingdom, Dynasty 18, about 1380 B.C.
Granodiorite; h. 79 ⅞ in. (203 cm)
From Thebes, Karnak, Precinct of the Goddess Mut

Sakhmet, whose name means "the powerful one," was one of the most belligerent and feared goddesses in the Egyptian pantheon, capable of destroying all humanity if provoked. The protectress of Egypt and avenger of the sun god Re, she is depicted as a lion-headed human (*left*) to convey the idea of her ferocity.

exist. Amun of Thebes, Bastet of Bubastis, and Ptah, the creator god of Memphis, were all part of local orders of gods and goddesses that developed over the centuries into a complicated and somewhat unwieldy religious system, which even the Egyptians had trouble understanding. An attempt was made to structure the relationships of the deities by uniting individuals together as a "family." At Memphis, Ptah, Sakhmet, and Nefertum, the deity of the swamps, were so linked, while at Thebes Amun, Mut, a mother goddess, and Khons, a moon god depicted as a young man, formed a family. ༄

Votive Images of the Gods Imhotep and Khons

Late and Ptolemaic Periods, 663-30 B.C.
Cast bronze; Imhotep: h. 5 in. (12.8 cm)
* Khons: h. 5 ⅛ in. (13 cm)*

The development of metalworking and casting techniques in the Late Period led to the production of countless images of gods and sacred animals for votive purposes and as offerings in temples and shrines. These images could range from mass-produced objects of little value to important miniature works of art, such as these two figures of exceptional quality. Imhotep (*right*) was the architect for the step pyramid of King Djoser. Later in Egyptian history, he was deified as the patron of scholars and doctors. He is shown here as a seated sage with an open papyrus scroll on his lap. The god Khons (*far right*) was originally a moon god but came to be considered in Thebes as the son of Amun and his consort, Mut. Here, his head is surmounted by the moon, and he wears the side lock indicative of a child. Wrapped like a mummy, he holds in his hands emblems of authority.

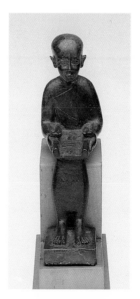
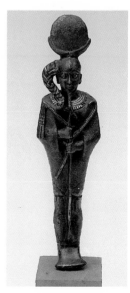

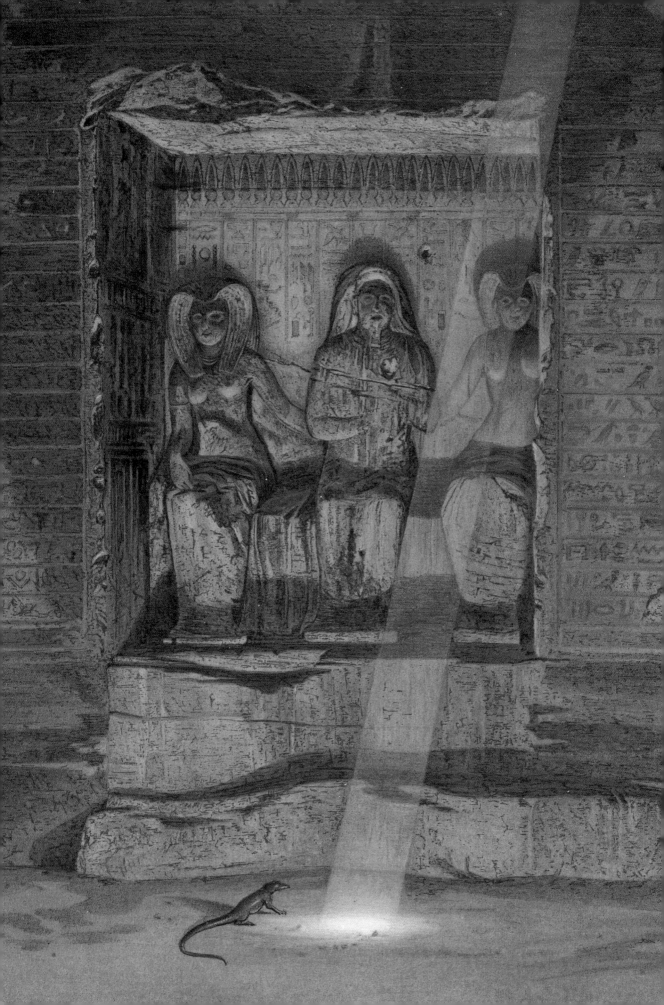

ASIDE FROM THE PYRAMIDS, mummies are probably the single group of objects most associated with ancient Egypt. The elaborate series of activities designed to preserve the body of the deceased was part of a complex effort to equip the spirit for every eventuality in the next life, which was envisioned in a number of ways. The spirit could join the gods in the "Land of the West," sail through the sky with the sun god in his boat, inhabit the tomb and receive food and other offerings, or assume different guises to enter and leave the tomb and associate with the world of the living. ᴄᴡ A belief in a life after death dates to the Predynastic Period and led

THE AFTERLIFE

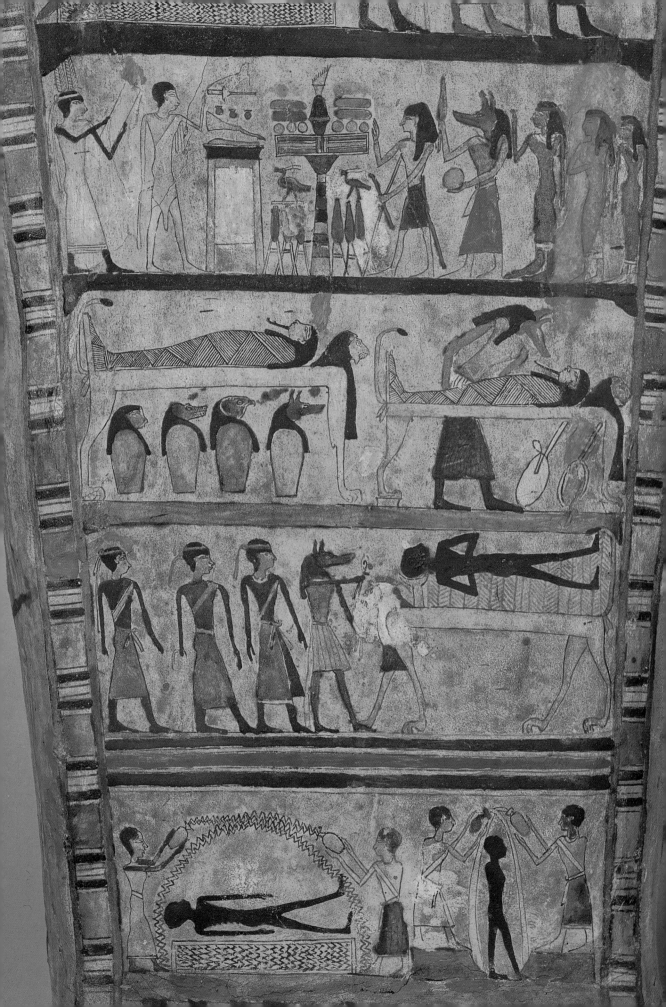

Sarcophagus of Djed-bastet-iu-ef-ankh

Ptolemaic Period, 2nd-1st century B.C.
Sycamore wood, linen, plaster, and paint; l. 69¼ in.
 (176 cm)
From el Hiba

The elaborate decoration of this sarcophagus, or coffin, consists of a painted head cloth, braided false beard, complex collar with falcon head terminals to hold the strands of beads in place, and a large-winged scarab beetle. The registers across the body (*left*) depict in detail the mummification process and the progress of the spirit of the deceased, represented as a shadow, to the next life. On the back of the coffin (*below, right*) is an image of a goddess with a sun disk on her head and holding a falcon and a jackal protecting the deceased.

the early inhabitants of the Nile Valley to place objects of daily life in graves for use in the spirit world. Some of the earliest known examples of Egyptian art were included as grave goods in early burials and were thus preserved. At first, the grave was a simple depression scooped out in the sand, perhaps protected by a pile of rocks placed on top after it was filled. The idea of preserving the remains of the dead probably originated with the observation that bodies placed in the dry sand of the desert and warmed by the hot sun naturally dried out and did not decay. Sometimes the body was wrapped in animal skin or reed matting and occasionally the

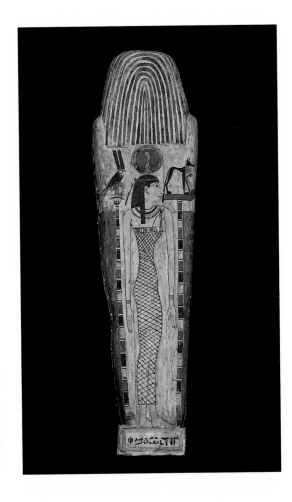

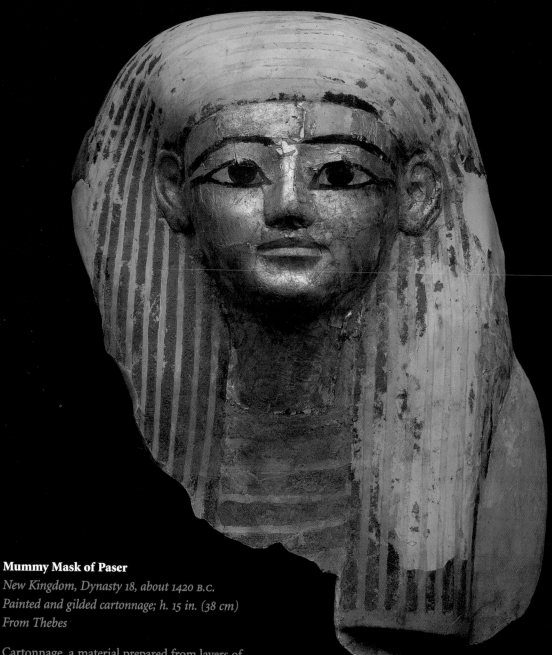

Mummy Mask of Paser

New Kingdom, Dynasty 18, about 1420 B.C.
Painted and gilded cartonnage; h. 15 in. (38 cm)
From Thebes

Cartonnage, a material prepared from layers of
linen, glue, plaster, and paint, was often used to
cover the face of a mummy or even the entire
body. This mask should be considered as an
idealized representation, not a portrait likeness,
of Paser, whose mummy has not survived. The
gilding of the mask has a reddish hue, which
recalls ancient Egyptian texts mentioning "the
gold that bled," apparently a property of the
metal that was found attractive.

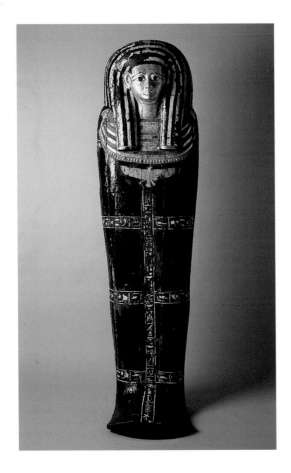

Anthropoid Sarcophagus of Paser

New Kingdom, Dynasty 18, about 1420 B.C.
Painted and gilded wood; l. 74¾ in. (190 cm)
From Thebes

Paser's mummy, decorated with the cartonnage
mask, would have been placed in this human-
shaped coffin. A golden vulture representing the
goddess Nekhbet, a deity of Upper Egypt, spreads
her wings across the figure's chest to protect the
deceased. The golden collar is decorated with
falcon heads. The combination of gold and black
suggests the colors of the night sky through which
the spirits of the dead had to make their way in
their progress to the next life.

burial pit was lined with boards.

During the early centuries of Egyptian
history, the process of preserving the body
became more elaborate. The use of a container
to hold the body was a natural development
in the search for better means of preservation.
The first coffins were small wooden boxes in
which the body was contracted; that is, folded
rather than laid out flat. These early boxes
resembled houses, leading to the notion of
the tomb as a house for the spirit. As this
idea became more prevalent, the coffins
became larger and were no longer buried
near the warm surface of the sand but in a
chamber located at the bottom of a tomb
shaft. The more elaborate burial arrangements
resulted in a need for a new way to preserve
the body and prevent the decay that previously
had been naturally arrested by the simple
heat of the sun. By the time of the building
of the pyramids, there was evidence of an
elaborate process of mummification that
had already been in use for nearly one hun-
dred years, at least for important royalty.

Mummification, in its simplest form, was
based on the premise that if the soft internal
organs—the brain, liver, lungs, stomach, and
intestines—were removed shortly after death,
and the corpse desiccated, or dried out, the
body would be preserved. The organs removed
from the body, which did not include the
heart, were kept in containers called Canopic
jars or boxes for protection. Usually four jars
were used, at first simple receptacles but
eventually decorated with heads in the shape
of a human, a falcon, a jackal, and a baboon.

Generally, the body was wrapped in linen
bandages and the area of the face covered by a

Sarcophagus of Kai-em-nofret

Old Kingdom, Dynasty 4, about 2480 B.C.
Red granite; h. 41 in. x l. 87⅜ in. (104 x 222 cm)
From Giza, tomb G II S

This early sarcophagus was designed to resemble the outward appearance of royal palaces, which were usually built of unbaked mud brick. Brick architecture utilized a pattern of recesses, reproduced on this coffin in miniature. The desired effect was to create an eternal home for the spirit that would associate the deceased with rulers and thus with the gods. The inscribed text on the sarcophagus reads simply "The Chamberlain Kai-em-nofret."

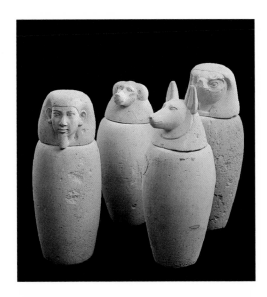

A Set of Canopic Jars
Late Period, 5th-4th century B.C.
Limestone; h. of tallest jar: 11¾ in. (30 cm)
From Abusir el-Meleq

As the mummification process became more elaborate, embalmers removed the body's soft internal organs and preserved them separately in jars such as these. The jars were placed under the protection of the four sons of the god Horus: the human-headed Imsety guarded the liver; the baboon-headed Hapy, the lungs; the jackal-headed Duamutef, the stomach; and the falcon-headed Qebehsenuef, the intestines. The heart, regarded as the seat of the soul, was left in the body.

mask, which helped to identify the individual within. The mummy was then put into a container, ranging from a simple wooden coffin for the lower classes to a series of elaborate cases for the well-to-do, to further protect it. Sometimes, a coffin was placed in a stone box, or sarcophagus, before being placed in the tomb.

Over the course of Egyptian history, additional stages and embellishments were added to the mummification process, but the basic procedure remained the same. In the Old and Middle Kingdoms, for example, the container for the mummy was a rectangular box made of either wood or stone. By the New Kingdom, however, the rectangular shape had been modified to resemble the contours of the body, producing an anthropoid or human-shaped coffin. These were made of wood and then painted or they were carved from stone. The elaborate nature of a royal burial in the New Kingdom is best illustrated by the regalia found in the tomb of Tutankhamun. The mummy of the young king bore a gold

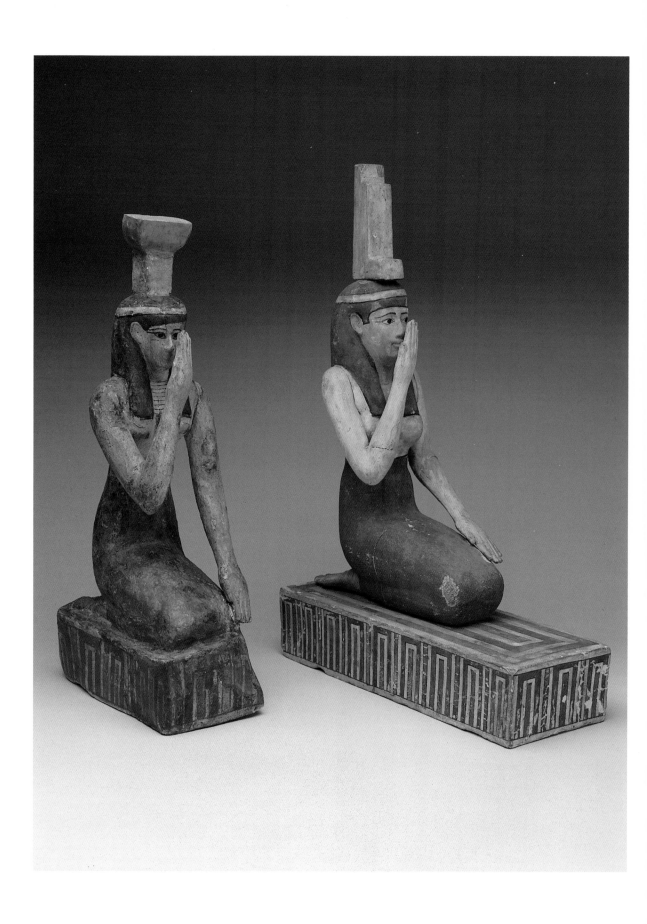

face mask and was placed inside three anthropoid gold coffins, which were in turn held in a granite sarcophagus all enclosed in four gilded wooden shrines within the tomb. His internal organs were contained in four miniature coffins placed in the four chambers of an alabaster box, each section with a stopper in the shape of the king's head. The box was then situated in a golden shrine.

Over the centuries, decorations beyond the face mask were added to the wrapped bodies. Amulets and charms of various kinds were included for both protection against evils and attraction of good. The amulets, objects worn by the living and attached to the body of the dead, protected against injury and illness and evoked life, health, stability, and other desirable qualities. They were

Nephthys, Isis, and Anubis
Early Ptolemaic Period, 3rd century B.C.
Wood, gesso, paint, and gilding; Nephthys: h. 13¾ in.
(35 cm), Isis: h. 16 in. (40.5 cm), Anubis: h. 16⅜
in. (42 cm)
Probably from Middle Egypt

In the ancient myth, Osiris, an early king, was murdered by his evil brother Seth and mourned by his wife, Isis (*left*), and her sister, Nephthys (*far left*). Through the efforts of his wife, Osiris's body was restored and he became the symbol of resurrection. The jackal-headed god Anubis (*right*), a protector of the necropolis or city of the dead, became the patron of the embalmers. Isis and Nephthys, identified by the hieroglyphs on their heads, are shown here kneeling in mourning. The figure of Anubis is richly decorated with painted corslet, kilt, armbands, and bracelets. The bases of all three figures are patterned to resemble the niches found in ancient royal architecture.

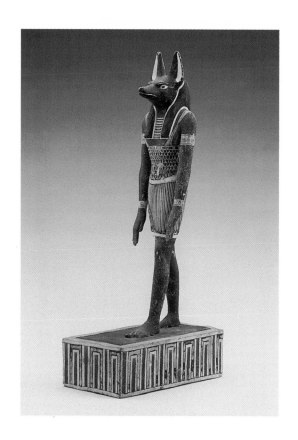

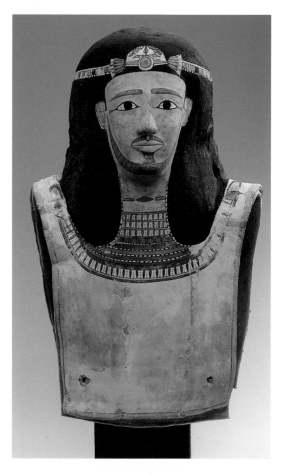

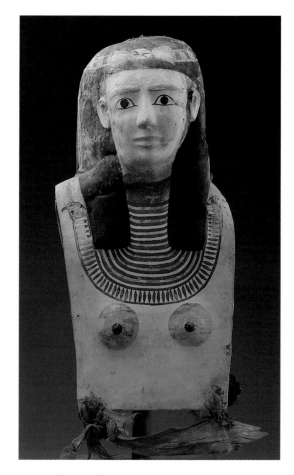

**Head Covering from the Mummy
of a Nobleman**

Middle Kingdom, Dynasty 11, about 2020 B.C.
Painted cartonnage; h. 20⅜ in. (51.8 cm)
From Asyut

Mummy masks and head coverings made of
cartonnage first appeared in Egypt at the begin-
ning of the Middle Kingdom, around 2000 B.C.
In this example, the deceased wears a mustache
and a neatly trimmed beard, a floral diadem on
his head, and a broad collar around his neck.

**Head Covering from the Mummy
of a Noblewoman**

Middle Kingdom, Dynasty 11, about 2020 B.C.
Painted cartonnage; h. 26⅛ in. (66.5 cm)
From Asyut

This woman's eyes are outlined with cosmetic
paint, and she wears an elaborate beaded collar
with falcon-headed terminals. The floral circlet
on her head is decorated with lotus flowers,
a symbol of rebirth. The figure's breasts are
emphasized to indicate her sex.

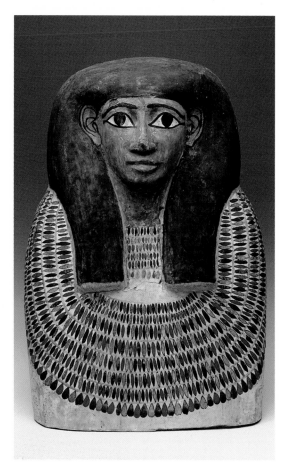

Upper Part of an Anthropoid Coffin

Late Period, Dynasty 26, 664-525 B.C.
Wood and painted plaster; h. 25⅝ in. (65 cm)

The shape of coffins evolved from the rectangular boxes used early in Egyptian history to the anthropoid, or human-shaped, variety, which began appearing in the Middle Kingdom, around 1800 B.C. This example is from the Late Period. The green face would have been a reference to Osiris, who was associated with that color in his capacity as a god of fertility and rebirth.

shaped in the form of hieroglyphic letters, such as the ankh, an abbreviation of the word for "life," or represented other objects. The scarab, shaped like a beetle, was an important example of the latter for it evoked the protection of the god Khepre, who was associated with the ideas of rebirth and regeneration.

It was considered important that the deceased not perform certain tasks or labor upon arrival in the next life. To that end, a special heart scarab with a short inscription asking that the spirit not do particular jobs was placed in the mummy wrapping as a charm. The notion of avoiding work was further reinforced by the placement of small mummy-form figures, called *shabtis*, in the tomb to act as substitute workmen. A "spell" inscribed or painted on many of the figures asked that if the deceased was called on to do any work in the next life, a shabti would answer in his place. These figures were as elaborate or simple as the tomb owner could afford, but there were almost always enough workers for every day of the year. In addition, there was also a *rais*, or overseer, for each squad of ten ordinary shabtis. The figures were equipped with basket, pick, and hoe since most of their duties had to do with the land, including cleaning drainage canals, preparing the fields for planting, moving sand from the east to the west, and other examples of hard labor.

In the first century A.D., mummy decoration showed the influence of the invading Romans. The three-dimensional mummy masks were sometimes replaced by flat panel paintings, showing the deceased with Roman

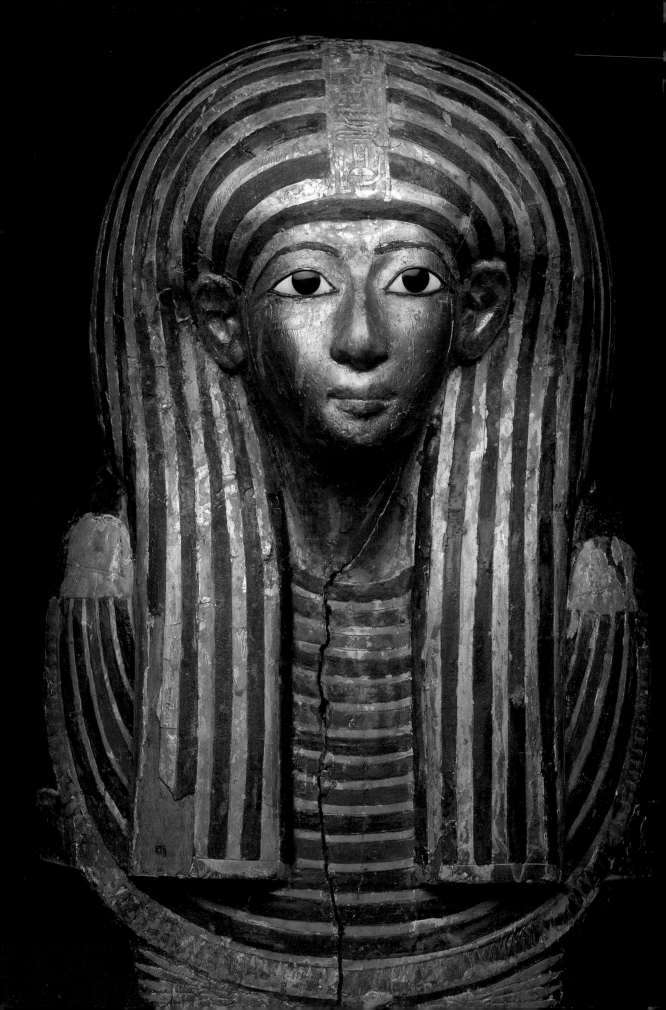

Anthropoid Sarcophagus of Amen-em-opet

New Kingdom, Dynasty 18, about 1490 B.C.
Painted and gilded wood; l. 81⅞ in. (208 cm)

According to the inscription on this coffin, Amen-em-opet was a military commander, the "overseer of the weapons bearers," in the time of the New Kingdom ruler Tutmosis I. Amen-em-opet's coffin is a carefully crafted work of art with black painted wood decorated with golden bands of inscription, a gold face and hair covering, and arresting eyes inlaid in contrasting colors of stone. The amount of gold used for decoration indicated the deceased's rank in society.

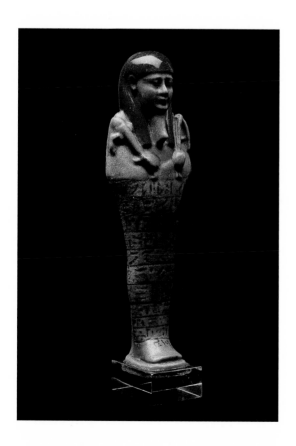

style hair, beards, and jewelry. With the coming of Christianity to Egypt, the mummification process was eventually abandoned. After the conquest of Egypt by Muslims, burial practices did not include any attempt to preserve the body.

The length of Egyptian history makes it almost impossible to generalize about any aspect of the society—from religious beiefs and the role of kingship to artistic representation and conceptions of the afterlife—all of which changed and developed through the centuries. Egypt's complex social structure produced pyramids and mummies, but those are only the best known of the ancient culture's accomplishments, which included inspiring works of architecture and art in many different media and a heritage of sophisticated literature and poetry. It is no wonder that the ancient Greeks and Romans believed that Egypt, one of the great civilizations of Africa, was the originator of many of the arts and sciences. ❧

Shabti Figure

Ptolemaic Period, 332-30 B.C.
Faience; h. 8⅛ in. (20.5 cm)

Shabtis, small human figurines, were placed in the tomb with the mummy to perform any tasks the deceased might be asked to do in the next life. Ideally, there would be more than four hundred such figures, one for every day of the year as well as one overseer for every squad of ten workers. The ordinary workers were wrapped like mummies and equipped with pick, hoe, and basket; in contrast, the overseers usually wore long kilts.

SELECTED GODS AND GODDESSES OF EGYPT

Amun—the great state god of Thebes in Upper Egypt, shown as a man with a high feathered crown

Anubis—the protector of the cemetery and patron of the embalmers, represented as a man with the head of a jackal

Aton—god of the sun disk, worshipped by the ruler Akhenaten as a creator god

Bastet—cat-headed goddess of the city of Bubastis

Bes—dwarf god with lionlike features, protector of women and children

Hathor—a mother goddess and personification of fertility, depicted with cow horns or as a cow

Horus—originally a sky god, was regarded as the son of Osiris and Isis; defeated Seth in combat and claimed the right to succeed his father as king, portrayed as a child in his role as the son of Osiris

Imhotep—architect of King Djoser's step pyramid, later deified as patron of scholars and healers

Isis—wife of Osiris, depicted with a throne, the hieroglyph for her name, on her head; sometimes shown with a sun disk and the horns of the goddess Hathor for a crown

Khepre—creator god closely associated with resurrection, often represented as a scarab beetle

Khnum—ram-headed god of the area of the first cataract of the Nile

Khons—a moon god, usually depicted as a young man with the moon disk on his head

Mut—a mother goddess and consort of Amun at Thebes, shown as a woman with the double crown of Upper and Lower Egypt

Nefertum—a god of vegetation, depicted with a lotus on his head

Neith—goddess of the city of Sais, shown wearing the crown of Lower Egypt

Nekhbet—vulture goddess of Upper Egypt, commonly depicted on royal regalia with wings outspread

Nephthys—sister of Isis, represented with a basket and a house, the two hieroglyphs for her name, "lady of the house," on her head.

Osiris—an ancient king, murdered by his brother Seth; became the principal god of the afterlife after his body was restored through the powers of his wife, Isis; represented as a man wrapped like a mummy with a tall crown bearing two feathers, face is often green because he was also a god of vegetation

Ptah—creator god of Memphis, depicted wrapped as a mummy

Ptah-sokar-osiris—a composite deity consisting of three gods of creation, death, and the afterlife

Patek—a protector god, portrayed as a bald-headed dwarf

Re—the sun god and creator god, sometimes represented as falcon-headed

Sakhmet—lion-headed goddess, protectress of Egypt and avenger for Re

Satis—a goddess of the region of the first cataract of the Nile, daughter of Khnum

Seth—murdered his brother Osiris and fought with Horus over right to succeed the dead king; represented as a man with the head of an unidentified animal with a long snout

Shed—a protector god, shown as a youth

Sobek—chief deity of the Faiyum, portrayed as a crocodile or man with a crocodile's head

Taweret—popular household goddess associated with women in childbirth, represented as a hippopotamus

Thoth—ibis-headed god, inventor of writing, patron of intellectual pursuits

Suggestions for Further Reading

Aldred, Cyril. *Egyptian Art.* New York: Oxford University Press, 1980.

Andrews, Carol. *Amulets of Ancient Egypt.* Austin: University of Texas Press/British Museum, 1994.

Baines, John and Jaromir Málik. *Atlas of Ancient Egypt.* New York: Facts on File Publications, 1980.

Brier, Bob. *Egyptian Mummies.* New York: William Morrow, 1994.

Edwards, I. E. S. *The Pyramids of Egypt.* New York: Viking, 1986.

Grimal, Nicolas. *A History of Ancient Egypt.* Cambridge, Mass.: Blackwell, 1992.

Houlihan, Patrick F. *The Animal World of the Pharaohs.* New York: Thames and Hudson, 1996.

Quirke, Stephen. *Ancient Egyptian Religion.* London: The British Museum, 1992.

Simpson, William Kelly, ed. *Ancient Egypt: Discovering Its Splendors.* Washington, D.C.: National Geographic Society, 1978.

Smith, William Stevenson. *The Art and Architecture of Ancient Egypt.* New York: Pelican, 1981.

Vercoutter, Jean. *The Search for Ancient Egypt.* New York: Harry N. Abrams, 1992.

For Younger Readers

Davies, W. V. *Egyptian Hieroglyphs.* Los Angeles: University of California Press/British Museum, 1987.

MacDonald, Fiona. *Ancient Egyptians.* New York: Barron's, 1992.

Mike, Jan M. *Gift of the Nile: An Ancient Egyptian Legend.* New York: Troll Associates, 1993.

Reeves, Nicholas. *Into the Mummy's Tomb.* New York: Scholastic/Madison Press, 1992.

Author's Acknowledgement

For valuable assistance in the preparation of this book, the author would like to thank Richard A. Fazzini of the Brooklyn Museum of Art and Emily Teeter of the Oriental Institute Museum, University of Chicago.—W.H.P.

Captions

Unless otherwise noted, illustrations at the beginning of each chapter are details from lithographs by David Roberts (Scottish, 1796-1864): p. 4–*Boats on the Nile (Shadouf at Gebel Silsila)*, 1828; p. 14– *The Colossi of Memnon in Thebes by Sunrise*, by C. Werner, 1870; p. 28– *The Pyramids at Giza*, 1839; p. 50– *The Great Temple of Abu Simbel*, 1838; p. 60– *The Pyramids and Sphinx at Giza*, 1838; p. 72– *Interior of a Tomb at El Kab*, 1838. Map opposite p. 1 by Mike Savitski.

INDEX

Page numbers in italics refer to illustrations

Afterlife, beliefs in, 73-75
Akhenaten, 2-3, 11, 55, 59
 Relief from a Temple of, *54*
Akhtaten (Tel el-Amarna), 3, 11
Amen-em-opet, Anthropoid
 Sarcophagus of, *84, 85*
Amenhotep III, 54
 and Queen Tiye, *55*
Amulets, 81-83
Amun, 21, 67, 71, 86
Animal and plant life, 8-13
Animals, as subject of Egyptian art,
 7, 8-9, 9, 11, 12, 13
Ankh, 10, 83
Anthropoid coffins, *74, 75, 77, 79,
 83, 84, 85*
Anubis, 81, 86
Arsinoe II, Queen, *58*
Artistic conventions, 45-49
Aton, 54, 65-67, 86
Atum, 63, 65-67

Ba-bird, *62*
Baboons, 67
Bastet, 12, 69, 71, 86
 The Goddess, *64, 65*
 The Sacred Cat of, *65*
Beards, false, 41, 63
Bes, 69, 86
Birds, as subject of Egyptian art, 11
Boat, depicted on early pottery, *6*
The Book of the Dead of Djed-hor,
 22-23, 24, 25, 27
A Brewer, *19*
Bubastis, 12, 65, 69, 71
Burial customs, 75-85

Canopic jars, *77, 79*
Cartonnage, *76, 77, 82*
Cartouche, 53
Cat, Sacred, of Bastet, *65, 69*
Cat with Kittens, *12*
Chariot, horse-drawn, *27*
Cherdu-ankh, Stela of, *13*
Christianity, introduction of, 3
Cleopatra, 55, 59
Coffins, *77, 79*; see also anthropoid
 coffins, sarcophagus
Coptic art, 3, *12*
Copts, 3
Cosmetics, use of, 39, 40
Cosmetic spoon, *10*
Craftsmen, 19
Creation myths, 63-65

Daily life of people, 17-19
Djed-bastet-iu-ef-ankh,
 Sarcophagus of, *74, 75*
Djoser, King, 71
Dwarf, symbolic meaning of, 37

Faience, 39
False Door of Princess Wen-shet, *33*
Fish, *8*

Geb, *63*
Giza, pyramids at, *2, 28, 31, 52, 59, 60*
Gods and Goddesses, 61-71, 86
Granary, Model of, *18*

Harvest Scene from the Tomb of
 Sesh-em-nefer IV, *16*

Hathor, 33, 41, 58, 67, 69, 86
Hatshepsut, Queen, 53
Hem-iu-nu, The Vizier, vii, *30, 31*
Hesi, Trumpeter, Stela of the, *35*
Heti, The Scribe, *20, 21*
Hieroglyphs, 22, 25
Hildesheim, vii
Hippopotamus, *11*
Horus, 11, 53, 65-67, 86
 sons of, 79

Ibis, *8-9*
Imhotep, 71, 86
 and Khons, Votive Images of, *71*
Iru-ka-ptah and His Wife, Funerary
 Statues of, *48, 49*
Isis, 63, 64, 69, 86
 and Nephthys, *80, 81*
 Ptolemy II Offering to, *59*
Iunu, Offering Relief of, *44*

Jewelry, 39-43

Kai-em-nofret, Sarcophagus of,
 78-79
Ka statues, *37, 49*
Kawi, Scribe, Funerary Stela of,
 26, 27
Khafre (Chephren), Head of, *52*
Khepre, 83, 86
Khnum, 86
 Psametik II Offering to, *57*
Khons, 71, 86
 and Imhotep, Votive Images of, *71*
Khufu (Cheops), vii, 31, 55, 59

Limestone
 Two Drawings on, *21*
 as writing material, 27
Linen, *17*
Lotus, *13*

Ma'at, 55
Mastaba tombs, 17
Memphis, 71
Middle Kingdom, 2
 images of rulers of, 53
 models of, *17, 18*
 tombs of, 79
Mirror, *41*
Monkey, symbolic meaning of, 37
Moses, the Scribe, Pyramidion of, *67*
Mummies, 73
 mummification process, 75-81
 mummy decoration, 81-85
Mummy of a Nobleman, Head
 Covering from, *82*
Mummy of a Noblewoman, Head
 Covering from, *82*
Mummy Portrait and Wrapping,
 38, 39
Muslims, 3, 85
Mut, 69, 71, 86

Nefer and His Wife, Offering
 Relief of, *37*
Nefer-ihi, Seated Statue of, *32*
Nefertum, 71, 86
Neith, 33, 86
Nekhbet, *77*, 86
Nephthys, 63, 65, 86
 and Isis, *80, 81*

New Kingdom, 2-3
 tombs of, *27*, 79
Nile River, importance of, 5-7
Nobility, 29-35
Nut, *63*

Occupational specialization,
 among Egyptian nobility, 33-35
Old Kingdom, 2, 29
 tombs of, 79
Osiris, 53, 83, 86
 myth of, 63-64, 81
 Statuette of, *63*

Papyrus, 11-12, 25-27
Paser
 Anthropoid Sarcophagus of, *77*
 Mummy Mask of, *76*
Patek, 86
Pelizaeus, William, vi-vii
Pelizaeus Museum, vi-vii
Pepy with Members of Her Family,
 31
Pharaoh, 57
Plant life, as subject of Egyptian art,
 11-13, *12*
Plowman, Model of, *17*
Pottery, predynastic, *6*
Predynastic Period, 2
 afterlife beliefs in, 73-75
Priests, 21
Psametik II Offering to the God
 Khnum, *57*
Ptah, *62*, 71, 86
Ptah-sokar-osiris, *62*, 86
Ptolemaic Dynasty, 3, 59
Ptolemy I, 47
Ptolemy II, 58, 59
 Offering to the Goddess Isis, *59*
Pyramid, Great, at Giza, *28, 31, 59, 60*

Rais, 83
Ramesses II, 55, 59
 Head of, *56*
 Lintel from a Chapel Dedicated
 to, *45*
Ramesses-mery-seti, 45
Re, 65-67, 86
Religious beliefs, 61-71
Roberts, David
 Boats on the Nile, 4
 The Great Temple of Abu Simbel, 50
 The Interior of a Tomb at El Kab, 72
 The Pyramids and Sphinx at Giza, 60
 The Pyramids at Giza, 28
Roemer and Pelizaeus Museum,
 vi-vii
Roemer, Hermann, vi
Roemer Museum, vi
Rosetta Stone, 22
Rulers, 51-59, 63

Sa-hathor, Seated Figure of, *32*
Sakhmet, 69, 71, 86
 The Goddess, *70, 71*
Sarcophagus, 79
 Anthropoid, of Amen-em-opet,
 84, 85
 Anthropoid, of Paser, *77*
 of Djed-bastet-iu-ef-ankh, *74, 75*
 of Kai-em-nofret, *78-79*

Satis, 57, 86
Scarab, 83
Scribes, 19-21, 35
 The Scribe Heti, *20, 21*
 The Scribe Kawi, Funerary Stela
 of, *26, 27*
 The Scribe Moses, Pyramidion of,
 67
Senebi, the Lady, Standing Figure of,
 34
Senwesret III, Fragmentary Head of,
 53
Sesh-em-nefer IV
 Harvest Scene from Tomb of, *16*
 Offerings to a Statue of, *36, 37*
Seth, 63, 64, 81, 86
Shabtis, 83, 85
 Shabti Figure, *85*
Shed, 86
 A Pectoral with an Image of, *66*
Shield, Ceremonial (Aegis), *68, 69*
Shu, 63
Sobek, 11, 86
Society, structure of, 15-17, 19-21
Sokaris, 47, 62
Sphinx, Great, *52, 60*
Sun gods, 65-67

Taweret, 11, 86
Tefnut, 63
Tel el-Amarna (Akhtaten), 3, 11
Thebes, 71
Thoth, 11, 67, 86
 Reliefs from the Chapel of, *46, 47*
Tiye, Queen, Amenhotep III and, *55*
Tomb Painting, Fragment of a, *27*
Tombs
 decorations on, 15
 goods in as measure of rank, 32
 mastaba, 17
 of Middle Kingdom, 79
 of New Kingdom, *27*, 79
 objects in, 15
 of Old Kingdom, 79
 representation of food production
 in, 19
 of Tutankhamun, 79-81
Tutankhamun, 55, 59
 tomb of, 79-81
Tutmosis I, 85
 Deified, *55*
Tutmosis III, 53

Wen-shet, Princess, False Door of, *33*
Werner, C.
 *The Colossi of Memnon in Thebes
 by Sunrise, 14*
Wigs, use of, 41
A Woman Grinding Grain, *19*
Women, as rulers of Egypt, 53
Writing, development of, 21-27